IMAGES
of America

EMPIRE RANCH

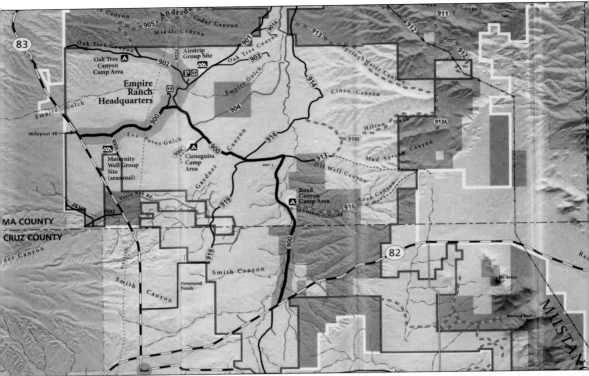

The Empire Ranch is in Las Cienegas National Conservation Area in southeastern Arizona. The property has been a working cattle ranch since 1876. The Bureau of Land Management (BLM) currently manages the historic ranch buildings in partnership with the Empire Ranch Foundation. The foundation works to protect and preserve the historic structures and landscapes of the Empire for future generations. (Courtesy of BLM.)

ON THE COVER: Walter Vail purchased the 160-acre Empire Ranch homestead in southeastern Arizona in 1876. He married his childhood sweetheart, Margaret Newhall, from Plainfield, New Jersey, in 1881 and brought her back to the Empire. Margaret, shown here during the 1881 roundup, was actively involved in the running of the Empire, in addition to raising six children in the harsh conditions of territorial Arizona. (Courtesy of Dusty Vail Ingram.)

IMAGES
of America

EMPIRE RANCH

Gail Waechter Corkill and Sharon E. Hunt
Foreword by Susan Vail Hoffman, Richard T. Schorr,
and Macfarland Donaldson

ARCADIA
PUBLISHING

Published by Arcadia Publishing
Charleston, South Carolina

Printed in the United States of America

Library of Congress Control Number: 2012941486

For all general information, please contact Arcadia Publishing:
Telephone 843-853-2070
Fax 843-853-0044
E-mail sales@arcadiapublishing.com
For customer service and orders:
Toll-Free 1-888-313-2665

Visit us on the Internet at www.arcadiapublishing.com

*Sharon: To my dogs, for unconditional support during the long
days and nights of writing, and, as always, to my father.*

*Gail: To Eldon Lee, my captain, my forever love,
who guides me from the North Star.*

CONTENTS

FOREWORD

My father was Edward Newhall Vail, the youngest son of Walter and Margaret. My first visit to the Empire was in 1998. I remember turning off the highway, onto the main ranch road, and the strong sense of belonging and connection took my breath away. I truly felt I had been here many times before. The sight of the majestic mountain ranges, the waving grasslands glimmering gold in the sun, and the contentment of the cattle grazing in that beautiful grass—I know how my grandfather must have felt the first time he saw the same sight. It is the same sense of wonder I feel each and every time I return to this special place. How incredible that the Empire Ranch is here for all who wish to visit and take a step back in time.

I feel this book is so important, to preserve the visual and written history of this wonderful ranch and surrounding area. This land has affected the lives of so many people, especially the hardworking families who nurtured and loved it, all of whom endured hardships that no one could understand unless they lived it.

—Susan Vail Hoffman

I first became aware of the Empire Ranch as the 12-year-old son of a rancher in nearby Canelo some 63 years ago. The magnitude of the Empire Ranch, which was owned and operated by the Boice family at the time, was evidenced each fall with the drive of thousands of cattle along the dirt road (now Highway 83) en route to the Sonoita railroad stockyards some eight miles south. There, the cattle were separated, weighed, and loaded onto 35–40 railroad cattle cars for shipment. The mother cows were then driven back to the ranch. All of this activity rendered the dusty dirt roads impassable at times, but it didn't bother the local folks, who came to watch this interesting event each year.

In keeping with the ranching traditions of this unique area, the Empire Ranch Foundation, which I have had the privilege of being a part of since its earliest years, has striven to preserve both the physical and the cultural qualities of this precious entity for future generations. Perhaps a youngster visiting the Empire Ranch now will take up the torch of the foundation to help perpetuate what I experienced as a young boy riding with the Empire Ranch cowboys and my father those many years ago.

—Richard T. Schorr

I first came to Empire Ranch in 1978 to help my father, John Donaldson, in our ranching operation. At that time, the Empire and Cienega Ranches were owned by Anamax Mining Company, and of utmost importance to them was the resource improvement of their holdings. My father's land stewardship ethic was a natural fit; consequently, a variety of management methods was implemented, and land health started to improve.

The 110 sections that encompass the Empire Ranch are varied and magnificent. I feel privileged to have assisted my father in our 34 years of tenure on it and to witness the ecological importance of its natural assets.

—Macfarland Donaldson

ACKNOWLEDGMENTS

This book would not have been possible without the enthusiastic support and encouragement of Carla Kerekes Martin, president of the Empire Ranch Foundation. Her leadership, humor, positive attitude, and communication talents have strengthened the foundation and furthered its mission to preserve and protect the Empire Ranch while moving it forward into the future. Gail wishes to thank Christine Auerbach, administrator of the Empire Ranch Foundation, who graciously welcomed her countless requests to seek out images for this book. Her enthusiasm, unique sense of humor, and friendship were constant sources of encouragement. Sharon wishes to especially thank Susan I. Hughes for her help and positive attitude.

We would also like to acknowledge the following individuals, who shared of their time and knowledge: Christine Auerbach, Gary Auerbach, Betty Barr, Ann Boice, Bob and Miriam Boice, Faith Boice, Murray Bolesta, Alison Bunting, Lily Cann, Drew Corkill, Mac and Billie Donaldson, Van Fowers, Susan Vail Hoffman, Susan I. Hughes, Gerald Korte, Annie Helmericks-Louder, Tony Luick, Ron Martin, Sarah and Paul Miller, Jackie Rothenberg, Dick and Leonor Schorr, Karen Simms, Netzin Steklis, and Kristin Tomlinson.

The photographs in the book are courtesy of the Empire Ranch Foundation (ERF), with the exception of those by Murray Bolesta, of CactusHuggers Photography, www.cactushuggers.com. Photographs that were donated by a specific individual to the foundation archives are identified by the individual's name.

INTRODUCTION

We had a splendid shower yesterday and another one today. The Ranch looks so beautiful.

—Margaret Newhall Vail

The Empire Ranch is located in southern Arizona on the east slope of the Santa Rita Mountains in the rolling grasslands and oak-studded foothills of the Cienega Valley. The story of the Empire begins in territorial Arizona in the summer of 1876, when William Wakefield sold his 160-acre homestead to Tucson merchant Edward N. Fish and business partner Simon Silverberg. In July, Walter L. Vail of New Jersey and Englishman Herbert R. Hislop departed Los Angeles by stagecoach bound for Tucson. Less than a month later, these two young men had purchased the homestead for $2,000 and established a partnership livestock operation.

Natural landforms in this valley create an ideal ranch spread for livestock. The acreage Vail and Hislop invested in was surrounded by the Rincon Mountains to the north, the Huachuca Mountains to the south, the Whetstone Mountains to the east, and the Santa Rita Mountains to the west. The seasonal rainwater that falls on these mountain ranges flows down to the basin and into the groundwater of the creek system. Vail and Hislop recognized that the land would be favorable for raising livestock because of its year-round water flow and native vegetation.

Realizing the need to increase their landholdings and cattle herd, they invited Englishman John Harvey to become a business partner. Personal financial matters at home, the threat of Apache raids, and trouble with a nearby sheepherder led Hislop to sell his shares to Vail for $6,850 in 1878. Hislop returned to England, vowing "never to return to this bloody country again."

After Hislop's departure, Vail and Harvey continued to acquire land along Cienega Creek. The Empire Ranch landholdings increased to 2,559 acres by 1884. Vail's older brother, Edward "Ned" Vail, joined the partnership in 1879. In 1881, cowboy John Dillon pointed out silver deposits on the northern pasture of the ranch. The Total Wreck Mine, named by Harvey, generated over $500,000 from 1881 to 1887. The money financed investments in more landholdings with controlling water rights in the region.

In April 1881, Harvey returned to England to marry his fiancée, Alice Maud Annan, and traveled back to the Empire in May. In June, Walter Vail returned to his hometown of Plainfield, New Jersey, to marry his childhood sweetheart, Margaret Russell Newhall. By August, Harvey had left the partnership.

From 1882 to 1896, Walter Vail, his partners, and Margaret transformed the 160-acre homestead into a profitable cattle-calf operation. Because of drought conditions in the early 1890s, Walter looked to California to expand the cattle enterprise. He and partner Carroll W. Gates leased acreage in San Diego County and kept the Empire as a breeding operation and moving the yearlings to California by train. When the Southern Pacific Railroad raised its shipping rates in 1890, Ned Vail undertook a cattle drive to California with 917 head of cattle. Two months later, 887 head arrived, at a profit of $4 more per head. In 1896, Walter moved his family and corporate headquarters to Los Angeles, leaving ranch foremen to manage the ranch.

Walter suffered severe injuries in Los Angeles on November 30, 1906, while helping Margaret as she stepped off a streetcar. He died three days later. At the age of 18 years, William Banning Vail, their third-eldest son, moved to the Empire to run the family operation. He married Tucsonan Laura Perry in 1913. Banning and Laura and their three children made the ranch their home.

In February 1928, after Walter's estate was settled, Margaret and her seven children sold the Empire to the Boice family, well-respected Arizona cattle ranchers, for $210,000. Brothers Henry, Frank, and Charles Boice took over operation of the Empire. Frank and his wife, Mary Grantham Boice, moved to the Empire in 1929 with their sons, Frank "Pancho" and Robert "Bob," while Henry and Charles operated nearby ranches.

During the 1940s, *Red River* and many other Hollywood films of the Western genre were shot on location at the ranch. Frank and Mary became sole owners of the Empire in 1951. They and their sons operated the ranch until Frank's death in 1956. Frank and his older brother Henry were leaders in the American cattle industry.

For the next 20 years, the Boices continued a purebred Hereford operation on the Empire. The future of the Empire became uncertain after Mary, Pancho, and Bob Boice sold the ranch to the Gulf American Corporation (GAC), a land development company. Pancho continued ranching on the Empire under lease arrangements with GAC until his tragic death in a plane crash in 1973. His son, Steve, then took over sole responsibility for the Empire cattle ranching operation. In 1975, real estate development plans for the ranch faltered, and GAC sold the ranch to the Anamax Mining Company for the water rights needed for a mining venture in the Santa Rita Mountains. The Boice lease arrangement ended.

Anamax brought in southern Arizona rancher John Donaldson in 1975 to manage the Empire. John's son Mac became a partner in 1978, and Mac's son Sam became a partner in 2003. In 1988, through a land swap, the US Bureau of Land Management (BLM) acquired the ranch lands and designated them as the Empire-Cienega Resource Conservation Area. The Donaldsons ranched the land under lease agreements with first Anamax and then BLM until March 2009.

In 1997, a group of private citizens formed the nonprofit Empire Ranch Foundation to preserve the historic buildings and history of the ranch for future generations. The foundation works in partnership with BLM to preserve and interpret the history of the Empire. The Empire Ranch is listed in the National Register of Historic Places.

In 2000, the US Congress designated the Empire Ranch and the Empire-Cienega Resource Conservation Area as Las Cienegas National Conservation Area. Today, the Tomlinson family of the Vera Earl Ranch in Sonoita, Arizona, continues ranching under a BLM grazing lease.

The tale of the Empire spans over 135 years. This book celebrates the ranching lives of the Vail, Boice, and Donaldson families and provides a glimpse into the struggles and successes of the ranch's men, women, and children who forged a "cattle ranching empire" in the grasslands of the Cienega Valley. The stories and images will resonate with generations to come.

One

HOPE AND DETERMINATION

I feel positive from all I hear that there is as fine grass land in this territory as there is in the world.

—Walter L. Vail

In the summer of 1876, New Jersey native Walter L. Vail and Englishman Herbert R. Hislop arrived in Tucson by stagecoach to find land and establish a partnership livestock operation. After scouting properties for two months, they purchased the 160-acre Empire Ranch homestead in the Cienega Valley of southeastern Arizona for $2,000 in gold coin. They set to work purchasing livestock, securing land from neighboring ranches, and making improvements to the ranch house—a four-room adobe structure with a flat roof and packed dirt floors built along the Empire Gulch of Cienega Creek.

To increase their landholdings and cattle herd, they invited Englishman John Harvey to join their partnership. The trio's ranch soon became known to the locals as the "English Boys' Outfit." By 1877, the English Boys' Outfit had increased its cattle holdings to over 800 head. Hislop returned to England in 1878 after selling his shares to Walter. Vail and Harvey continued to expand the Empire, and Walter's brother Edward "Ned" joined the partnership. They discovered silver deposits on their land, and the Total Wreck Mine generated income to expand the Empire even further.

Walter married childhood sweetheart Margaret Newhall in 1881. That same year, Harvey married and left the partnership, selling to Margaret "all my rights, title, and interest in my house and furniture situated on the Empire Ranch" for $1,000. Walter and Margaret made the Empire their home from 1882 to 1896, raising six of their seven children there and, along with their partners, transforming the Empire into a profitable cattle-calf operation that controlled 100,000 acres of rangeland and ran 40,000 cattle at its peak.

In 1896, Walter moved his family and corporate headquarters to Los Angeles, and ranch foremen took over management of the Empire. Walter died in a streetcar accident in 1906. In 1907, Walter's son Banning was sent to the Empire to learn the cattle business, and in 1913, he took over as Empire Ranch manager. He, his wife Laura, and their three children made the ranch their home. Margaret and her children sold the ranch to the Boice family in 1928, but the Vail family's considerable legacy at the Empire and contributions to Arizona ranching history were ensured.

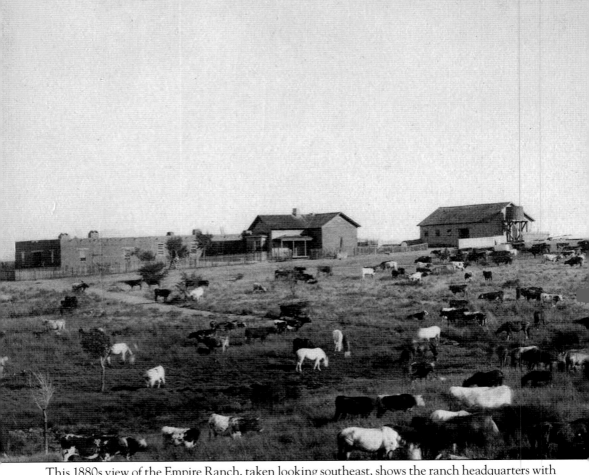

This 1880s view of the Empire Ranch, taken looking southeast, shows the ranch headquarters with grazing cattle and horses. Seen in the foreground is a steady, spring-fed stream that flowed north to Cienega Creek. This reliable water source and the thick, drought-tolerant native grasses and shrubs were the assets of the property that led partners Walter L. Vail and Herbert R. Hislop to purchase the 160-acre homestead from Tucson businessmen Edward N. Fish and Simon Silverberg in 1876. Shown from left to right are the ranch's original four-bedroom adobe home, the Victorian addition to the house, the adobe hay barn, and the water tank. Adobe is made of a mixture of straw, clay, and water, which is shaped into bricks and dried in the sun. Adobe structures were common in territorial Arizona—being extremely durable, composed of readily available materials, and cooler in the heat than wooden buildings. (Courtesy of Dusty Vail Ingram.)

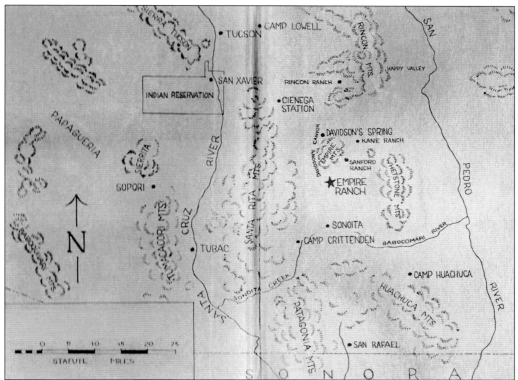

The Empire Ranch is situated in the Cienega Valley of southeastern Arizona, about 45 miles southeast of the city of Tucson. The Santa Cruz and San Pedro Rivers bracket the west and east. To the east lie the Whetstone Mountains. The United States–Mexico border is approximately 50 miles south of the Empire Ranch headquarters. (Hislop, *An Englishman's Arizona*.)

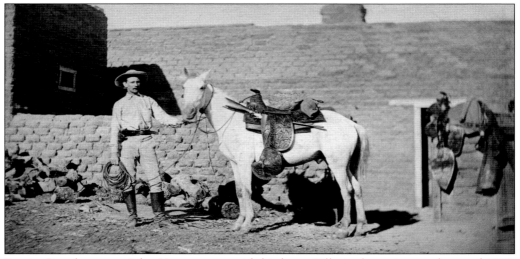

Empire Ranch partner John Harvey poses with his horse Billy in the main corral around 1880. The corral was attached to the house to keep the livestock safe at night from rustlers. Harvey, just 23 when he came to the area, helped expand the ranch. He left the partnership in 1881. (Courtesy of Dusty Vail Ingram.)

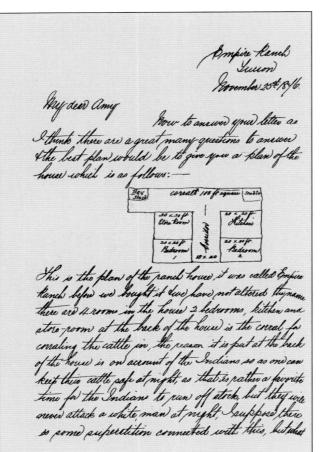

My dear Amy,

Now to answer your letter as I think there are a great many questions to answer & the best plan would be to give you a plan of the house which is as follows:—

[sketch of house plan with rooms labeled: Hay Stack, Corral 100 ft square, Stable, 30 x 30 ft Store Room, 20 x 20 ft Kitchen, 20 x 20 ft Bedroom 1, 18 x 20, Bedroom 2, zaguan in middle]

This is the plan of the ranch house, it was called Empire Ranch before we bought it & we have not altered the name there are 4 rooms in the house 2 bedrooms, kitchen and store-room at the back of the house is the corral for corraling the cattle in, the reason it is put at the back of the house is on account of the Indians so as one can keep their cattle safe at night, as that is rather a favorite time for the Indians to run off stock, but they will never attack a white man at night, I suppose there is some superstition connected with this, but what

During his time on the Empire, Herbert Hislop wrote a series of letters to his sister Amy Tate in England. This 1876 letter includes a sketch of the flat-topped adobe house with its dirt floor and glass-free windows. The house had two bedrooms, a kitchen, and a storeroom, with a zaguan (from the Spanish for breezeway) running down the middle to the adjoining adobe-wall corral. (Hislop, *An Englishman's Arizona.*)

The Empire Ranch cook points out the cook's wing to female visitors in 1885. The group is looking toward the zaguan, a corridor running past the Vail and Hislop bedrooms to the corral, where the livestock were kept at night. The zaguan was the only entrance to the corral, and it was unlikely that a thief could have taken off with the Empire livestock. (Courtesy of Dusty Vail Ingram.)

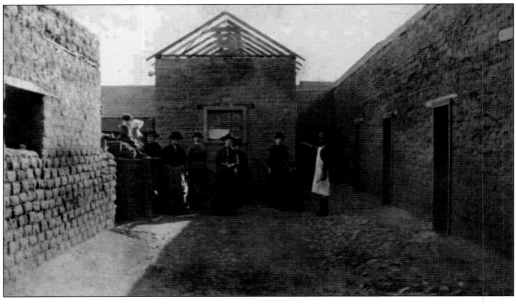

Walter L. Vail is about 30 years old in this portrait. Ranch life involved long hours and hard work. Vail once said, "We lost 27 horses and colts on Saturday, I spent Sunday looking for them. When I got home I found that the horses had returned home about an hour after I left. I was rather mad with myself for riding hard all day for nothing." (Courtesy of Dusty Vail Ingram.)

The Empire Land and Cattle Co. was formed in 1883, with Walter Vail as the principal shareholder. Carroll W. Gates became his partner in 1889. After the death of Walter, the company was renamed the Vail Co. The image on the left side of the letterhead is based on a photograph of two horses holding a bull between them.

Walter Vail was born in Halifax, Nova Scotia, in 1852. By his sixth birthday, his family had moved to New Jersey, where his father owned grain farms and a mill. This photograph shows the Vail family home in Plainfield, New Jersey, in the 1880s. On the day he turned 21, Walter left New Jersey to seek his fortune in the West. (Courtesy of Dusty Vail Ingram.)

This photograph of Margaret Russell Newhall was taken around 1880. Margaret and Walter Vail were childhood sweethearts in New Jersey. They wed in 1881, and Margaret moved to the Empire soon after. Together, they had seven children, six of whom were raised on the ranch. (Courtesy of Dusty Vail Ingram.)

Edward L. "Ned" Vail, Walter's older brother, joined the Empire Ranch partnership in 1879. Ned was a prodigious writer as well as a cattleman. He left behind letters, a diary, and newspaper articles describing the life of an Arizona cattleman. (Courtesy of Dusty Vail Ingram.)

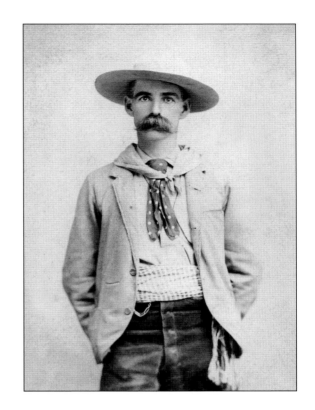

This photograph of Edward L. "Ned" Vail, Walter's brother, was taken in 1890. After moving to the Empire in 1879, Ned remained in southern Arizona his entire life, moving to Tucson in 1908, where he was an important figure in the business community. He remained a lifelong bachelor but was a beloved uncle, nicknamed "Tio," to Walter and Margaret's children. (Courtesy of Dusty Vail Ingram.)

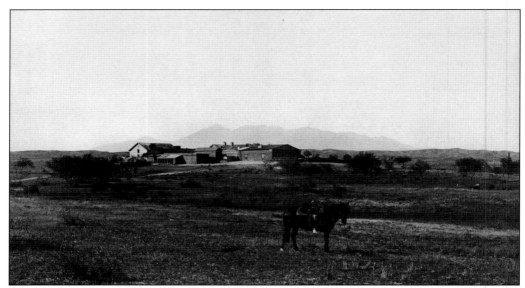

This northeast view of the ranch in 1890 shows partner Edward "Ned" Vail's horse in the foreground. Ned left New York to join his brother Walter in Arizona in 1879. Together, the two brothers bought all the available acreages in the area, particularly those with controlling water rights. In addition to raising cattle, beginning in 1884, the Vails bred horses. (Courtesy of Dusty Vail Ingram.)

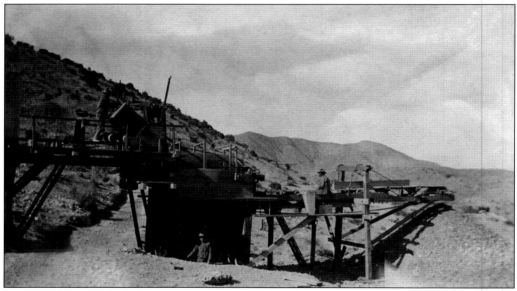

In 1879, silver was discovered on the northern pastures of the Empire Ranch, near the town of Pantano, Arizona. The silver mine, named the Total Wreck Mine, was operated by Ned Vail from 1881 to 1887. The mine generated more than $500,000 in revenue, supplying much of the capital needed to expand the ranch's cattle operation through the purchase of more land and cattle and improvements to ranch headquarters. (Courtesy of Dusty Vail Ingram.)

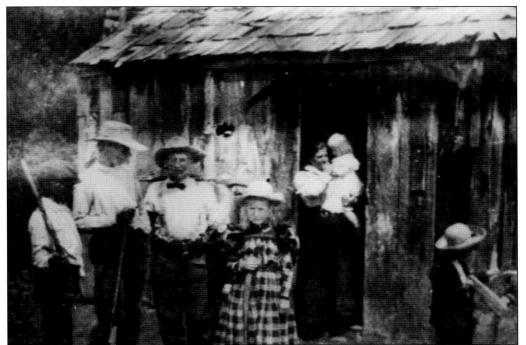

In this 1898 photograph, Margaret Vail holds her youngest daughter, Margaret, while standing in the doorway of this building at Mescal Springs Ranch in Whetstone Gap east of the Empire. Walter bought this ranch property to control the range operations in that area. Her sons Russ, Mahlon, and Walter Jr. are also in the photograph, though not identified. The Vail family was visiting Arizona at this time from their home in Los Angeles. (Courtesy of Dusty Vail Ingram.)

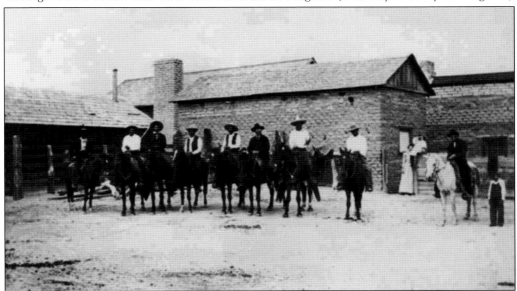

During the Vail era on the Empire Ranch, the cowhands were primarily vaqueros from southern Arizona. In this 1880s photograph, the ranch's vaqueros line up in the stone corral before heading out to work. Behind them is the cook's wing of the homestead. (Courtesy of Dusty Vail Ingram.)

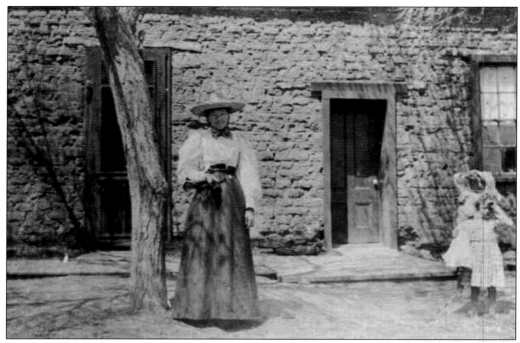

Hadden V. McFaddin was the foreman at the Empire from 1896 to 1900. He and his family lived in the Empire Ranch headquarters. Here, his wife, Mattie, poses in front of the west side of the rear addition of the adobe homestead in 1880. At the right are their children, Perry and Esther. (Courtesy of BLM.)

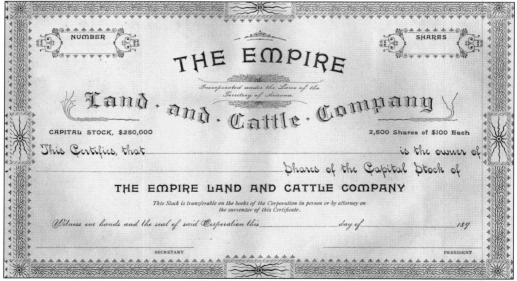

In 1886, the ranch was incorporated as the Empire Land and Cattle Company. California entrepreneur Carroll W. Gates purchased a half-interest in the company in 1889. Vail and Gates expanded the cattle operation, leasing property in California, Kansas, Oklahoma, and Texas. Vail was an astute businessman, adjusting his cattle operations to meet changes in the cattle industry and making the Empire one of Arizona's largest and most influential livestock operations.

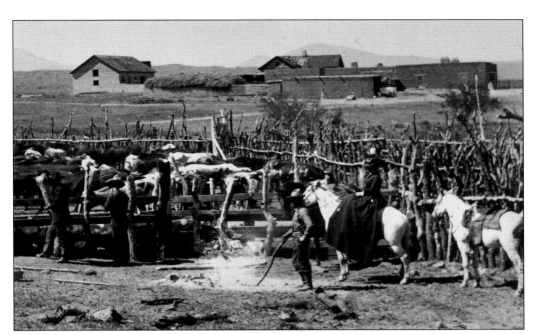

Margaret Vail is shown riding her horse sidesaddle in front of the cattle corral during the 1881 Empire Ranch roundup. One of the Empire's cowhands is pictured next to her. Margaret was an active participant in the running of the ranch while raising six children in the harsh, isolated setting of the Empire. (Courtesy of Whitney Vail Wilkinson.)

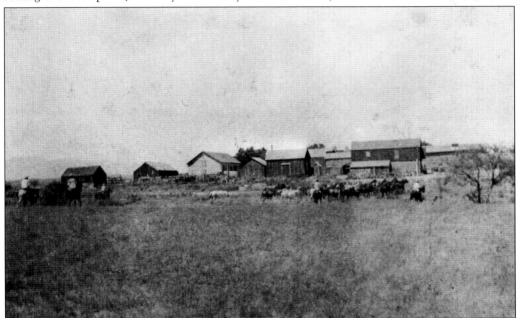

In this 1900 photograph, cowhands are seen moving the stock into the corral next to the Empire Ranch House. By this time, the Empire was a thriving cattle ranch with a complex of buildings. Walter Vail had moved his family to Los Angeles in 1896, with the ranch foreman taking over management of the Empire. (Courtesy of Dusty Vail Ingram.)

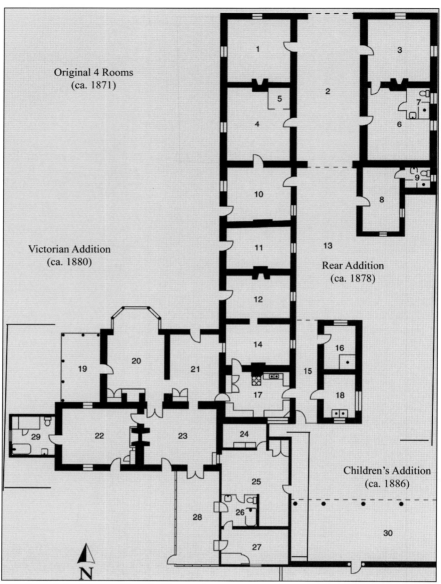

Original 4 Rooms
(ca. 1871)

Victorian Addition
(ca. 1880)

Rear Addition
(ca. 1878)

Children's Addition
(ca. 1886)

N

This floor plan of the Empire Ranch House shows its expansion from 1871 to 1886. The original adobe homestead had four rooms: rooms 1 and 3 were partners Walter Vail's and Herbert Hislop's bedrooms; room 4 was originally the kitchen and then the cowboys' dining room. Vail and Hislop added windowpanes, doors, and a wooden floor to the house, hiring two Native American adobe masons to help them with their renovations. The rear addition was added in the late 1870s to accommodate the ranch staff and business, and consisted of the following: the foreman's quarters (8), the cowboys' kitchen (10), Walter Vail's office (11), the bookkeeper's quarters (12), the family cook's quarters (14), and the kitchen used to prepare the Vail family meals (17). The gable-roofed Victorian addition, built around 1880, included the following: the front porch (19), the living room (20), the dining room (21), the master bedroom (22) and bath (29), and the guest room (23). The wooden-frame children's addition was built in the 1880s: rooms 24–27 were a closet, two bedrooms, and a bath used by the Vail children. Today, the house has 22 rooms.

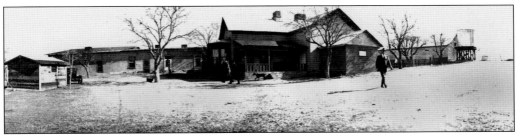

This photograph of the west side of the Empire Ranch House was taken around 1920. John Harvey built the first three rooms of the 1878–1881 Victorian addition to the house, shown in the middle of the photograph. Walter Vail installed the half-hexagon bay window in the north wall of the living room in 1881 as a wedding present for Margaret. (Courtesy of Dusty Vail Ingram.)

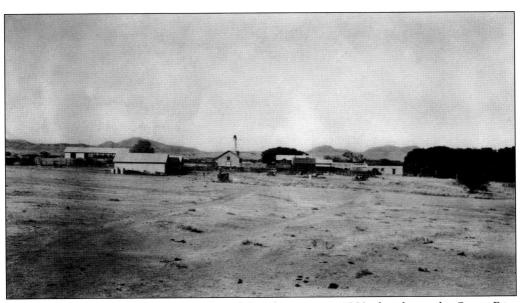

This panoramic view of the Empire Ranch headquarters in 1923 also shows the Santa Rita Mountains to the west. The buildings (left to right) are the south barn, mechanic's shop, adobe hay barn, and Empire Ranch House. On the right side are the cottonwoods along the Empire Gulch. (Courtesy of Dusty Vail Ingram.)

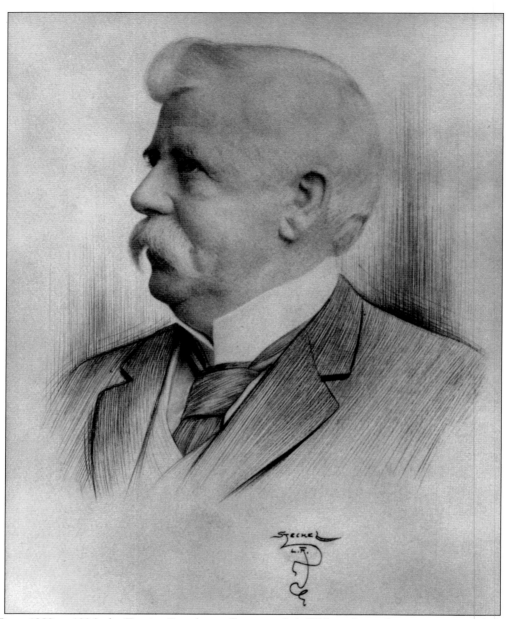

From 1882 to 1896, the Empire Ranch rapidly expanded. Walter, shown here, incorporated the Empire Land and Cattle Co. in 1883, retaining ownership of all but 2 of the 2,500 shares. He actively bought land in southern Arizona to increase the ranch's water supply and support cattle grazing. Walter, concerned about overgrazing in Arizona, then looked for property in California. In 1888, he and a partner, Carroll W. Gates, bought a ranch in San Diego County. The Empire became primarily a breeder operation, with the cattle moved as yearlings to California to fatten up. Walter, Margaret, and their six children moved to Los Angeles in 1896 to better manage the California holdings. Walter died in a streetcar accident there in 1906, leaving Margaret, his children, and his partners to continue his cattle ranching legacy. At the time of his death, the Empire Ranch covered almost 100,000 acres. (Courtesy of Dusty Vail Ingram.)

William Banning Vail was the third-eldest son of Walter and Margaret Vail. In 1907, he was sent back to the Empire from the Vail home in California to learn the cattle business. He took over the running of the Empire in 1912. Banning died of pneumonia in 1936 at just 46 years of age, approximately six years after this photograph was taken. (Courtesy of Dusty Vail Ingram.)

Banning Vail, manager of the Empire Ranch from 1912 to 1928, balances on the cutting chute used to separate cows into two or more holding corrals. After the Empire was sold in 1928, Banning and his family moved to Los Angeles, where he continued to be active in the Vail family's ranching empire. (In memory of William "Bill" and Evelyn Vail.)

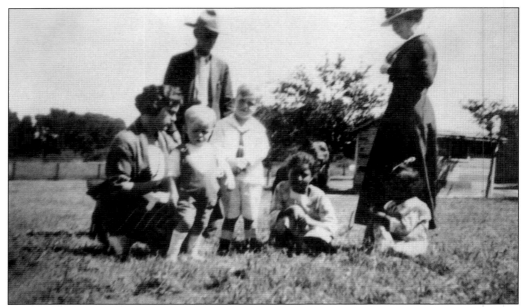

Members of the Vail family pose outdoors in their finery in 1921. Shown are, from left to right, (in front) Laura Perry Vail and her sons Tom and Bill, Freida Brown (daughter of the Vail family cook, Lena Brown), an unidentified friend, and Agnes Vail (sister of Walter and Ned); (standing in back) Ned "Tio" Vail and the family dog. (Courtesy of Dusty Vail Ingram.)

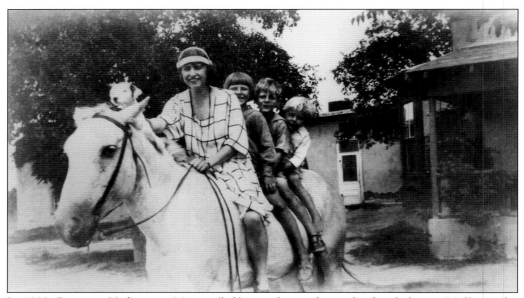

In 1923, Banning Vail's sister Margie (left) goes for a ride on the family horse, Molly, in the yard of the Empire Ranch House. The children shown here are, from left to right, Laura Perry "Dusty," William Banning "Bill," and Thomas Edward "Tom." They are Banning and Laura Perry's children. The family dog, Buttons, is perched on the horse's head. The three children grew up on the Empire. (Courtesy of Dusty Vail Ingram.)

Margaret Vail beams at her granddaughter, Dusty, daughter of Banning and Laura Perry Vail, who smiles broadly for the camera. Margaret was affectionately called "Nana" by her grandchildren. This photograph was taken in the Empire Ranch House in 1916, when Dusty was one year old. (Courtesy of Dusty Vail Ingram.)

Dusty Vail stands by the south barn wearing her new chaps in 1923. According to Dusty, "I was more interested in the horses and the cattle and doing things with dad" than in gardening or housework. The south barn was constructed by her dad, Banning, to serve as a horse barn, storage area, and blacksmith/repair shop. (Courtesy of Dusty Vail Ingram.)

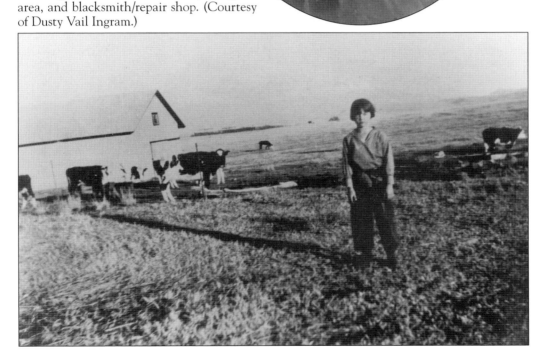

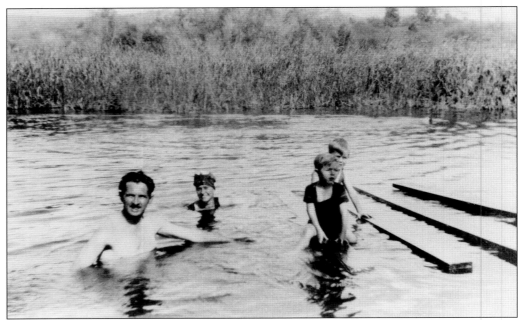

Every member of the Vail family worked hard making a success of the ranch, but they had time for fun as well. The Monkey Springs swimming hole in nearby Patagonia, Arizona, provided relief from the desert heat. Shown here in the 1920s are, from left to right, Randolph Nicholas Randolph (a friend of Margie's), Margie Vail, Tom Vail, and Bill Vail. (Courtesy of Dusty Vail Ingram.)

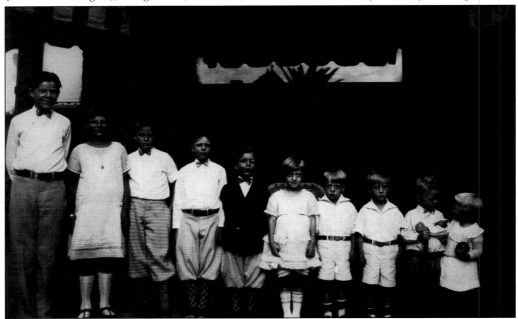

The grandchildren of Walter L. Vail line up for a portrait in 1925. Walter and Margaret had seven children and 22 grandchildren. Shown here are, from left to right, Granville, Dusty, Buzzie, Bill, Tom, Margaret, Russ, Al, Sandy, and Mary. Dusty, Bill, and Tom grew up on the Empire. (Courtesy of Dusty Vail Ingram.)

Two

A FAMILY ENDEAVOR

It was a good life. I had a great time. All my heroes were cowboys.

—Robert "Bob" Boice

The epic tale of the Boice family's efforts to run a successful purebred Hereford operation on the Empire began in 1891, when well-known cattleman Henry S. Boice arrived in Arizona to contract steers. He accumulated ranches in Missouri, Texas, New Mexico, the Dakotas, and Oklahoma and had connection by marriage to the well-established Hereford bull import firm of Gudgell & Simpson. While manager of the XIT Ranch in Texas, Boice began investing in the Chiricahua Cattle Company (CCC), one of the largest ranches in the territory of Arizona. By 1909, Boice had bought all the CCC stock and organized the outfit under the name Boice, Gates, and Johnson. He bought 400 of the XIT purebred Herefords and moved the herd to Arizona in 1912.

The influx of homesteaders forced Boice to cut his operation in Sulphur Springs Valley and increase the cattle known as the "Cherry Cows" on the San Carlos/Fort Apache Reservations. Boice died in 1919, leaving the operation to his eldest son, Henry Gudgell. In 1924, Henry and brothers Frank and Charles purchased the Eureka Ranch as the first step to moving 20,000 cattle off the reservation. In 1927, the Office of Indian Affairs discontinued issuing permits.

In 1928, the Vails sold the Empire Ranch to the Boices; the brothers acquired two nearby ranches, the Rail X and Arivaca. Frank and Mary Boice managed the ranch until they became sole owners in 1951. As Hollywood romanticized the West, the Boices hosted many film stars, including John Wayne, who starred in *Red River*, one of many movies filmed at the Empire Ranch. In 1969, the Boices sold the Empire to the Gulf American Corporation (GAC). Sons Pancho and Bob, and later Pancho's son Steve, continued ranching under lease arrangements with GAC until 1975.

The legacy of four generations of the Boice family is deeply rooted in the cattle ranching heritage of the rangelands of the West—one that is an indelible part of the Arizona cattle industry.

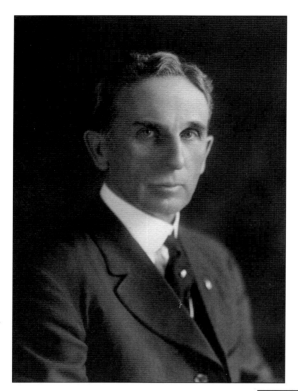

Henry Stephen Boice was a prominent cattleman, trail driver, and pioneer of Hereford cattle operations that extended from New Mexico, southeastern Colorado, southwestern Kansas, and the Texas Panhandle to the North Dakota badlands and across Arizona rangelands. He had a reputation for his refusal to smoke, drink, or swear and for having "a will like a rock." (Courtesy of Bob and Miriam Boice.)

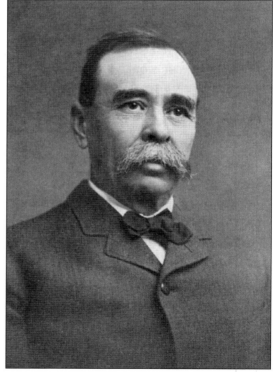

This is a portrait of Charles Gudgell, father-in law of Henry S. Boice. In 1879, he established Gudgell & Simpson, the first firm to import registered, purebred Hereford bulls to breeders in Missouri. Gudgell traveled to England and returned with the bull Anxiety 4. The firm became recognized as one of the greatest breeding enterprises of Hereford cattle in the United States. (Courtesy of Bob and Miriam Boice.)

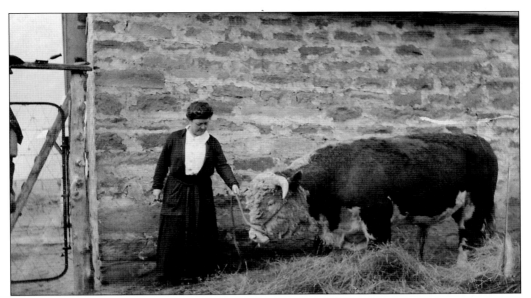

LuBelle Boice shows off Beau Gaston in this c. 1900 photograph. Beau is a descendant of Anxiety 4, the "father of American Herefords." Henry Boice's interest in buying Herefords led him to the firm of Gudgell & Simpson. Boice went to Independence, Missouri, to buy several prize Herefords from Charles Gudgell. There, he met Gudgell's daughter, LuBelle. They married in 1892 and had three sons and two daughters. (Courtesy of Katherine "Kitty" Boice Collection.)

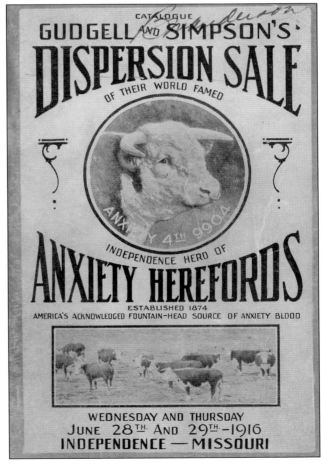

This image, featuring the famous Anxiety 4, is from the 1916 cover of the catalog of the Gudgell & Simpson Dispersion Sale. Gudgell & Simpson founded the first purebred Hereford herd in Missouri. In 1912, Henry S. Boice brought purebred Hereford bulls to southeastern Arizona from the XIT Ranch in Texas. (Courtesy of Bob and Miriam Boice.)

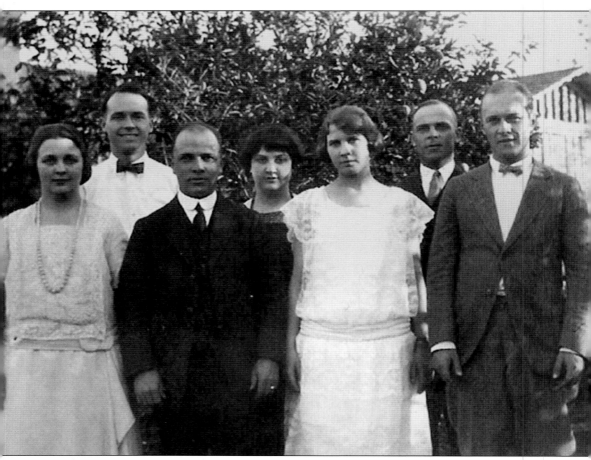

Frank Seymour Boice married Mary Forester Grantham of Light, Arizona, in Tombstone in 1923. Brothers Henry, Frank, and Charles Boice, born to cattle ranching, carried on in the footsteps of their father, Henry. The Boice family poses here at Frank and Mary's wedding. They are, from left to right, (first row) LuBelle Boice, Frank Boice, Mary Grantham Boice, and Charles "Tyke" Boice; (second row) Walter Young, Helen "Bunny" Boice, and Henry Boice. In 1929, Frank and Mary moved to the Empire Ranch with their sons, Frank Stephen and Robert Grantham, and they became sole owners of the Empire in 1951. (Courtesy of Bob and Miriam Boice.)

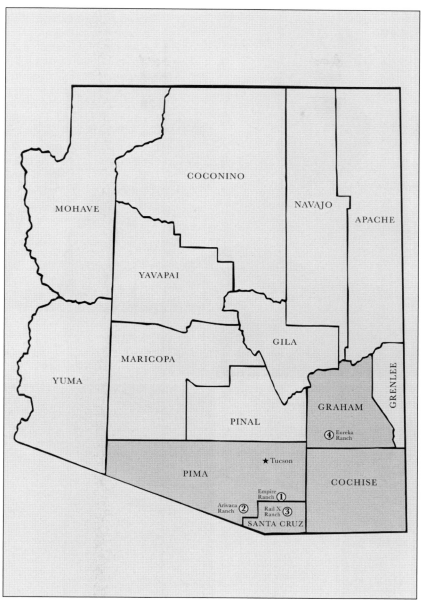

The map shows the state of Arizona with its counties labeled: COCONINO, MOHAVE, NAVAJO, APACHE, YAVAPAI, GILA, MARICOPA, YUMA, GRENLEE, GRAHAM, PINAL, PIMA, COCHISE, SANTA CRUZ. It marks ★ Tucson, and the ranch locations: Empire Ranch ①, Arivaca Ranch ②, Rail X Ranch ③, and ④ Eureka Ranch.

On February 15, 1928, the Boice brothers, as part of the Chiricahua Ranches Company, bought all the lands, state and federal land leases, possessory rights, water rights, and the property known as Empire Ranch from the Vail family for the price of $210,000. Cowhands who worked for the Boices nicknamed the operation the "Cherry Cows," after the CCC brand of the Chiricahua Cattle Company outfit situated in the Sulphur Spring Valley near Willcox, Arizona. Henry S. Boice—father of Henry, Frank, and Charles Boice—purchased the CCC stock from John V. Vickers in 1909. The company was named after the Chiricahua Mountains. The name Cherry Cows was much easier for the cowboys to say and remember than Chiricahua (chi-ri-cow-wah). The map pinpoints the locations of the four early, well-known ranches they purchased between 1924 and 1928 to extend their range holdings in southern Arizona. (Graphic design by Drew Corkill.)

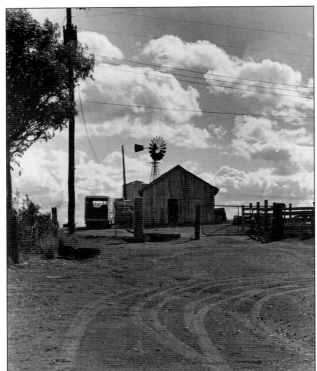

From 1928 to 1929, the Boices reorganized the Chiricahua Ranches Company and divested parts of Empire property to respond to the US Forest Service's restrictions on the number of cattle a lessee could run on government land. Pictured here is the south barn, with a gasoline pump and gate made from a metal bed frame. During the Boice era, Hollywood directors used the north room as a movie set. (Courtesy of Katherine "Kitty" Boice Collection.)

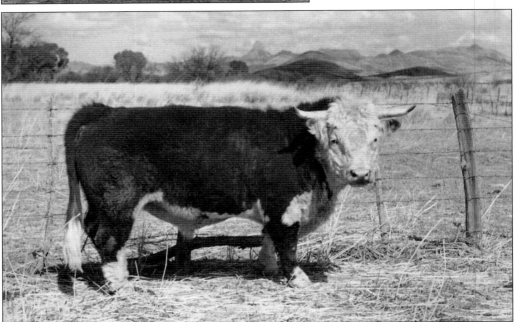

The hearty Hereford bull staring at the camera is Junior, son of Number 43. The Boices' Hereford breeding stock was moved from the Eureka Ranch to the Empire Ranch in 1938. The topography of the Empire was more suitable for dividing the land into pastures, so each bull was given its own herd. The bull-cow ratio was 1:30–35. (Courtesy of Katherine "Kitty" Boice Collection.)

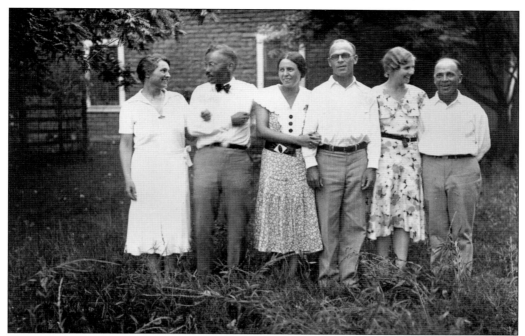

Through the 1930s and 1940s, Frank and Mary ran the Hereford operation on the Empire Ranch with the help of sons Pancho and Bob. By 1951, they had full control of the property. Henry managed the Arivaca Ranch (southwest of Tucson) in the 1930s, while Charles managed the Rail X Ranch (between Sonoita and Patagonia) from 1930 to 1945. Shown in the above photograph are, from left to right, Sarah and Dr. Clarence Gamble, Margaret and Henry Boice, and Mary and Frank Boice. They are posing in the south garden, in the 1950s. The iris beds Mary so loved once bordered the entire backyard and front yard to the Delco power plant located at the south corner of the front yard. The below photograph shows the front yard, where an unidentified woman is catching a ride on the sideboard of the car around 1929. (Above, courtesy of Ann Boice; below, courtesy of Bob and Miriam Boice.)

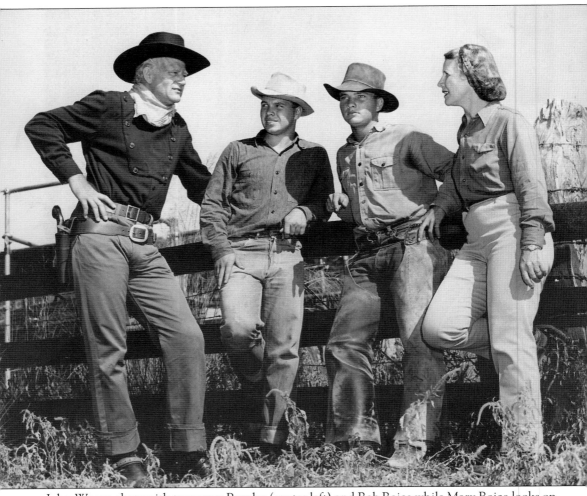

John Wayne chats with teenagers Pancho (center left) and Bob Boice while Mary Boice looks on during the filming of *Red River* on location at Empire Ranch headquarters. The Boices hosted many movie actors and directors from the 1940s to the 1960s, including actors Montgomery Clift, Jennifer Dru, Kirk Douglas, Burt Lancaster, and Rhonda Fleming, and directors Howard Hawks and Arthur Rosson (1948, *Red River*) and John Sturges (1957, *Gunfight at the O.K. Corral*). During the Boice era, other movies and popular TV series were filmed on or near the Empire Ranch, including *Duel in the Sun* (1946), *Oklahoma!* (1955), *3:10 to Yuma* (1957), *Bonanza* (1959–1973), and *Gunsmoke* (1955–1975). In the late 1940s, Frank and Mary added many modern conveniences to the Empire Ranch House. Natural gas was piped into the house and plumbing was upgraded. The swimming pool, installed in the garden south of the master bedroom, became the focal point for many family gatherings and parties at the Empire Ranch House. (Courtesy of Katherine "Kitty" Boice Collection.)

Young Steve Boice is standing tall in front of Burt Lancaster in this 1955 photograph. Lancaster holds Steve's younger sisters Katherine "Kitty" (left) and Sherry at Empire Ranch headquarters. Lancaster, Kirk Douglas, and Rhonda Fleming were on location to film *Gunfight at the O.K. Corral*. (Courtesy of Katherine "Kitty" Boice Collection.)

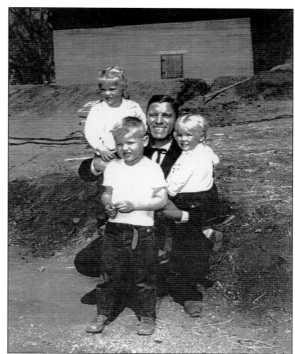

Actor Anthony Quinn (far left) and director Hal Wallace (far right) pose with Mary Boice (first row, second from left) and Sonoita ranchers Bob and Mary Bowman during the filming of *Last Train from Gun Hill* in 1959. This movie was among many that were shot on location at Empire Ranch. (Courtesy of Mary Bowman.)

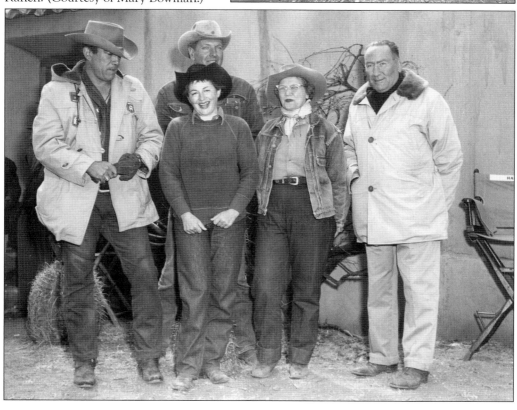

Frank S. Boice stands near the cowboy kitchen in this 1940s photograph. He received a graduate degree in mechanical and electrical engineering from the Massachusetts Institute of Technology and, during World War I, developed a submarine detector for Western Electric Laboratories. In 1920, he moved to his father's Chiricahua Cattle Ranch near Pearce, Arizona, to help manage the Chiricahua Cattle Company's off-reservation operations of the "Cherry Cows." According to cowhand Jack Cooper, Boice was "kind of a jokester." Cooper recollected a conversation he had with Boice when Cooper worked on the Empire Ranch: Boice said, "Jack, you do know where that roundup is down there." Cooper replied, "By golly, Frank, I don't know. I'm about half lost." Boice's comeback was, "Yeah, you're about half lost from everything but the bean pot." (Courtesy of Verne Steen.)

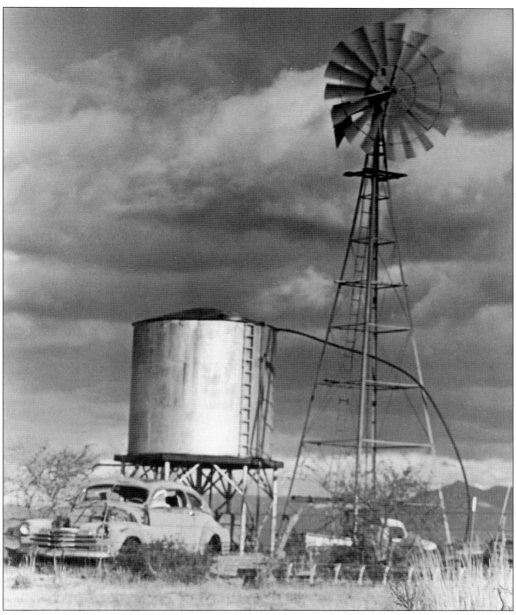

The water tank and windmill shown here were probably installed by Frank Boice in the late 1940s or early 1950s. Frank added about 25 mechanically dug wells to make sure water was readily available to cattle as they grazed in the expansive pastures of the Empire. Norman Hinman was as a cowhand for Frank Boice for four months during the spring and summer of 1953. He worked with Frank and Frank's sons Pancho and Bob to check the windmills and equipment to ensure they were operating properly or if the equipment needed repair. Norman said how impressed he was with the ranch operation, especially with the ingenious water tanks and troughs Frank designed and constructed. He is still amazed by the elongated, water fountain–type trough Frank devised that streamed water out faster than a cow could drink. (Courtesy of Katherine "Kitty" Boice Collection.)

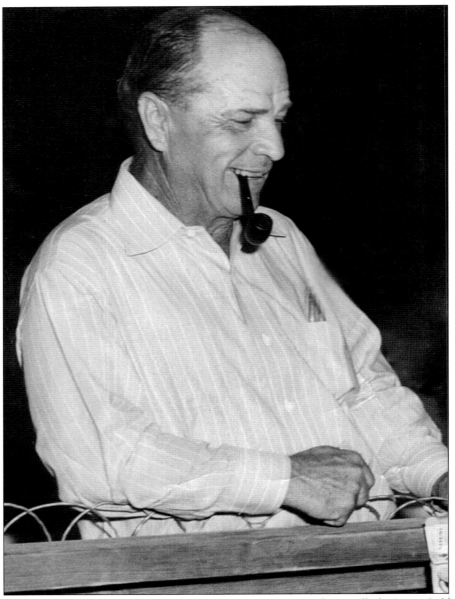

Frank Boice smiles down at his daughter-in-law Miriam (not pictured) at a rally for Barry Goldwater. Frank was president of the Arizona Cattle Growers' Association from 1935 to 1936. In 1940, he was elected president of the American National Livestock Association during the difficult years when there was a struggle to put the cattle industry under government controls, price supports, and subsidies. He organized the National Livestock Tax Committee and served as chairman from 1940 until his death in 1956. Under Boice's leadership, the committee was able to get the capital gains provision written into the tax law to benefit cattle growers across the country. For his services to the National Cattlemen's Beef Association, he was elected to the Cowboy Hall of Fame in 1958. He was well respected by the University of Arizona's College of Agriculture and Life Sciences for his support of research on the Empire to evaluate cattle and by the Arizona cattle industry for his efforts on rangeland mesquite eradication. (Courtesy of Bob and Miriam Boice.)

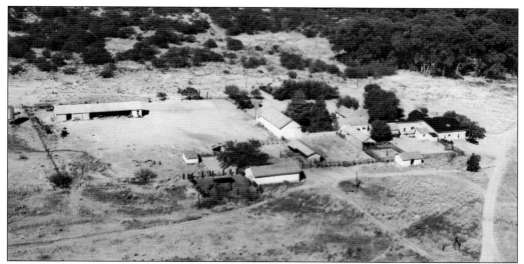

This photograph is an aerial view of Empire Ranch headquarters in 1957. When Blas Lopez, who lived at the ranch as a boy, was 80, he told Mary Boice that he and his father planted five cottonwood switches in the cienega (from the Spanish for marsh) north of headquarters. These switches, planted nearly 100 years ago, grew into a cottonwood canopy shown pictured along the Empire Gulch (top). (Courtesy of Katherine "Kitty" Boice Collection.)

Pancho Boice (left) is pictured with his uncle Henry in the annual selection of replacement heifers on the Empire Ranch in 1959. Henry is recognized as an influential leader in the Arizona cattle industry. He was president of the Arizona Cattle Growers' Association from 1921 to 1928 and the American National Livestock Association from 1930 to 1933. (Courtesy of Katherine "Kitty" Boice Collection.)

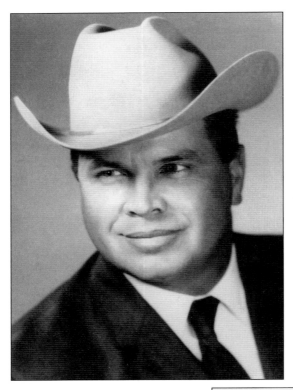

Frank Stephen "Pancho" Boice was director of the Arizona Livestock Production Credit Association, vice president of the Arizona National Livestock Show, and president of the Arizona Cattle Growers' Association from 1970 to 1971. In 1973, at age 47, he was killed when the private plane he was flying crashed on the Navajo Reservation on the way to his home in Colorado. (Courtesy of Bob and Miriam Boice.)

Robert Grantham "Bob" Boice managed the Empire with his brother Pancho until 1955 and then operated the family-owned Slash S Ranch south of Globe, Arizona. In the family tradition, he was a member of the National Cattlemen's Association and the Arizona Cattle Growers' Association. Bob served as chairman of the Society of Range Management and president of the Gila County Cattle Growers Association. In 1998, he received a Lifetime Achievement Award from the University of Arizona, College of Agriculture, for his contributions to Arizona ranching. At 84 years old, Bob died at his home in Globe on June 21, 2012. (Courtesy of Bob and Miriam Boice.)

Steve Boice (left) looks on as his father Pancho brands cattle in the corrals east of Empire Ranch headquarters. From 1969 to 1973, Steve helped his father manage the Empire under a grazing lease with the Gulf American Corporation. Steve became solely responsible from the time of Pancho's death in 1973 until 1975. Steve, his wife, Annie, and their infant daughter, Faith, were the last Boices to live in the Empire Ranch House. (Courtesy of Annie Helmericks-Louder, Jean Aspen.)

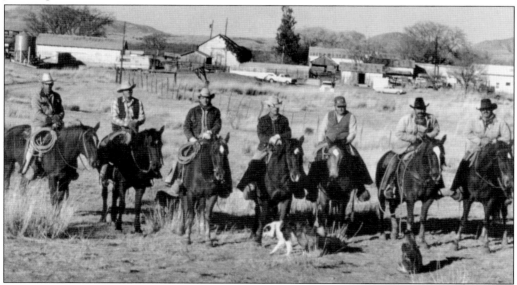

The last roundup of the Boice Hereford breeding herd was held on the Empire Ranch in the winter of 1975. It took Steve Boice and the cowboys in the photograph nearly three weeks to round up the cattle. Shown here are, from left to right, Bailey Foster, Pete Ortega, Grant Boice, Bob Boice, Steve, Johnny Leveen, and Joe Leveen. (Courtesy of Bob and Miriam Boice.)

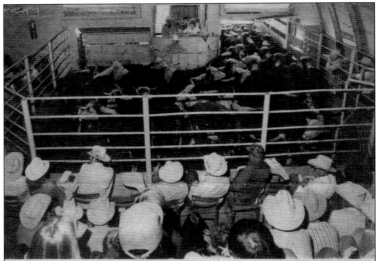

Citizen Photo by Bruce Hopkin

Let 'em in, boys . . .'

Auctioneer Jack Nelson starts his chant as the breeding herd of Empire Ranch near Sonoita is sold at the Nelson Livestock Auction, 4555 N. Highway Drive. The herd, descended from cattle brought to Arizona 63 years ago from Texas, had been the pride of the Boice family in Sonoita for generations.

Hereford breeding herd of Empire Ranch is sold

By FRANK ALLEN
Citizen Business Editor

The entire breeding herd of the Empire Ranch has been sold at auction in Tucson, scattering forever some of the finest Hereford bloodlines in the Southwest.

Brought to Arizona in 1912 from the sprawling XIT Ranch in Texas, the herd has been the pride of the Boice family in Sonoita for generations.

The auction yesterday was understated dramatically. It showed in the list of queries from ranchers in Oregon, Nebraska, Colorado, Nevada and other states, who chose not to come only because most of the 700 pregnant cows would have their calves in January and February — months before the northern winter would be over.

It showed in the leathery faces of the buyers from Oklahoma, New Mexico and Arizona, whose eyes darted from the livestock in the sale ring to the notebooks cupped in their palms and back to the livestock.

It even showed in the melodic voice of the auctioneer, who interrupted his staccato monologue more than once to comment on the quality of the herd.

"We just don't see a herd like this one every day,' said auctioneer Jack Nelson. "I've been in Arizona 16 years and before that, I was in Nebraska. I can't remember many that would compare. Nobody would quarrel with you if you said it was among the finest in the Southwest."

The herd belonged to the family of Robert G. Boice, of Globe, and to the estate of his late brother, Frank. In a matter of a few hours, the 890 animals — including 70 bulls — that had taken nearly three weeks to round up had been dispersed among 18 buyers.

The bulls brought an average of $347 a head. The pregnant cows brought an average of $256.

Boice sat with his family at the edge of the sale ring after the crowd had dissipated and stared out toward the stock pens. He tugged at his Stetson and remembered aloud that cows from the same herd had brought $300 each in 1951.

The Boices brought the cattle to the Empire Ranch from another part of the state in 1928. Forty years later, the ranch was sold to Gulf American Corp. About a year ago, GAC sold the property to Anamax Inc.

The mining company did not renew the Boices' grazing lease and the family had no other spread suitable for the herd, so it had to be sold.

The cows were all direct descendants of the original Gudgell & Simpson herd, brought to this country from England.

Pictured here is a *Tucson Citizen* news article on the Empire Ranch cattle sale in 1975. The entire breeding herd of the Empire Ranch was sold at the Nelson Livestock Auction in Tucson. Buyers from Oregon, Nebraska, and other states noted that the Boice herd was among the finest Hereford bloodlines in the Southwest. The herd belonged to the Robert "Bob" Boice family and to the estate of Pancho Boice, his late brother. The herd included 70 bulls, which sold for an average of $347, and 700 pregnant cows, which sold for an average of $256. In 1951, the same herd, Bob Boice remarked, would have brought in $300 each. The Boice Herefords were descendants of the nationally known Hereford breed of Gudgell & Simpson, established by Bob and Pancho's great-grandfather, Charles Gudgell. (*Tucson Citizen*, December 20, 1975.)

Three

HEART AND HEARTH OF THE EMPIRE

Since the Chiricahua Cattle Company, we re-organized and all of the "desert" part was sold. At present the Empire Ranch consists of about 60 sections of land. It is the "heart" of the original holdings, which we hope operate for years to come.

—Mary Grantham Boice

The story of the women of the Empire Ranch is the story of the power of enduring love, faith, joy, sorrow, and inspiration.

Margaret Vail, Laura Vail, Mary Boice, Sherry Boice, Miriam Boice, Annie Helmericks Boice, and Billie Donaldson shared, with the men they fell in love with and married, an affinity with the Empire. Each learned to adapt to the realities of a very different yet satisfying way of life in the remote place in the Cienega Valley they called home.

As wives and mothers, they maintained fine households and provided their families with a warm, comfortable home knitted in love and devotion. They did so with the adoration of their husbands and the support of nearby relatives, as well as with the goodness of those who lived on the Empire and in the ranching community.

Margaret, Mary, Laura, and Sherry had to survive the sudden deaths of their husbands. Each found the strength to raise her children without a father and make tough decisions to survive. In time, they moved on, with the memories of the "good life" they knew and loved on the Empire.

Mary Eliza Vail and Margaret "Margie" Vail were endeared by their niece and nephews. The adventurous Laura "Dusty" Vail emulated the "cowboy spirit" of the Empire Ranch. Eva Ferra Jimenez lived her childhood years there, and, as a young woman, helped Mary Boice in the care of her sons. Dorothy Fisher, well-respected Empire Elementary School teacher, taught several of the Boice children.

Today, the Empire Ranch House remains a reminder of the conviction of each of these remarkable women, who collectively left an echo whispering softly down the way of their hopes and dreams and of lives well lived on the remote Empire Ranch.

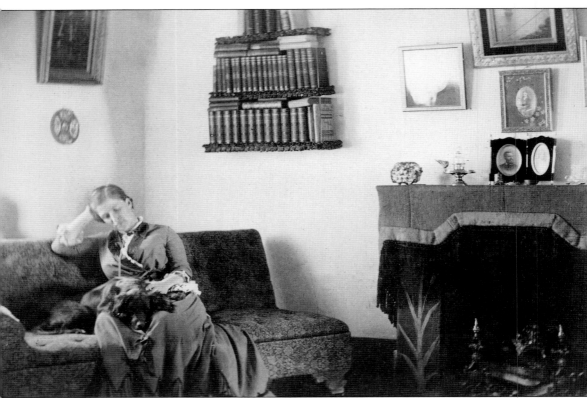

Margaret Russell Newhall was born in December 1854 in Cincinnati, Ohio. Her mother, Mary Jane Russell Newhall, established a home for her daughter and two sons in Dunellen, New Jersey, after her husband's death. Margaret met Walter L. Vail shortly thereafter. Walter gave Margaret a little gold wedding ring when she was about 12 years old. Fifteen years later, on June 15, 1881, Margaret married Walter at Holy Innocents Chapel, the Episcopal church in New Market, New Jersey. Uncharacteristically for the day, she brought to the marriage a dowry—money she had earned from her work as a professional singer performing at concerts and community events in New York and New Jersey. Margaret's $10,000 dowry was used, in part, to purchase the house John Harvey had built for his bride, Alice, on the Empire Ranch. Astute in business, Margaret conferred with Walter on land acquisitions. Walter remarked that because of Margaret's good business sense and the welcoming home she created, she made more cattle sales than he did. In this c. 1882 photograph, Margaret relaxes in the parlor of the Victorian addition to the Empire Ranch House with her dog. (Courtesy of Dusty Vail Ingram.)

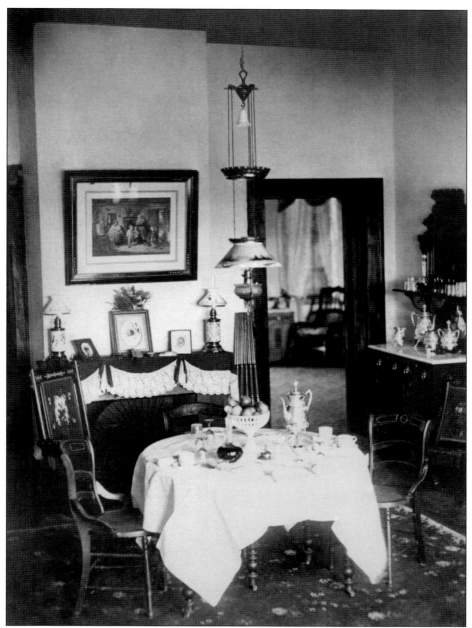

Six weeks after their wedding, Walter Vail returned to the Empire Ranch without Margaret. On August 5, 1881, he wrote: "My darling Maggie . . . I expect you will be saying that I have forgotten you as old, that is as you used to say as old, but the reason there has been no chance to send you a letter as last night was the first through mail either way and in it I received seven letters from my darling. . . . Mr. Moor, Uncle Nathan, and myself left the Ranch this morning and stopped here. . . . In the morning we will drive to Tombstone . . . and will return to the Ranch next day if all goes well and then I will have to spend a week . . . at the Ranch and Mines, after which I will start back to see My Darling once more." This photograph from the 1890s shows the parlor in the Empire Ranch House set for high tea. (Courtesy of Dusty Vail Ingram.)

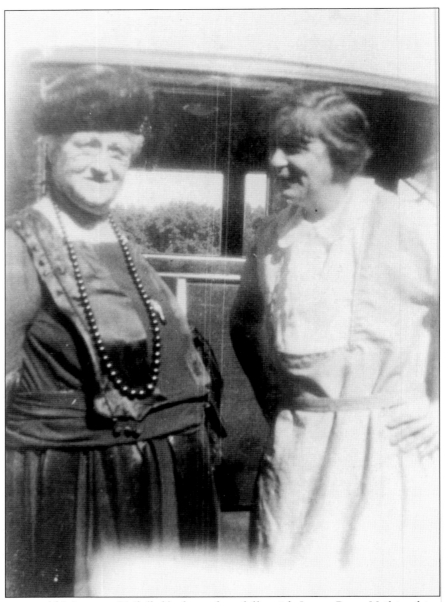

Seventy-year-old Margaret Vail (left) chats cheerfully with Laura Perry Vail in this c. 1924 photograph. It was probably taken at Empire Ranch when Margaret traveled to visit her son Banning, daughter-in-law Laura, and grandchildren Dusty, Bill, and Tom. Margaret, always stately in appearance, often wore a large hat and always dressed in black after the death of her husband, Walter Vail. The Empire Ranch House was a source of pride for both Margaret and Laura. In fact, Laura aspired to create a comfortable yet "modern" home for her family and friends on the Empire—one that was far from the home and city life she was accustomed to in Tucson. Margaret's grandchildren loved to visit her house in Los Angeles for family gatherings at Christmas and spend time with her over their summer vacations. (Courtesy of Whitney Vail Wilkinson.)

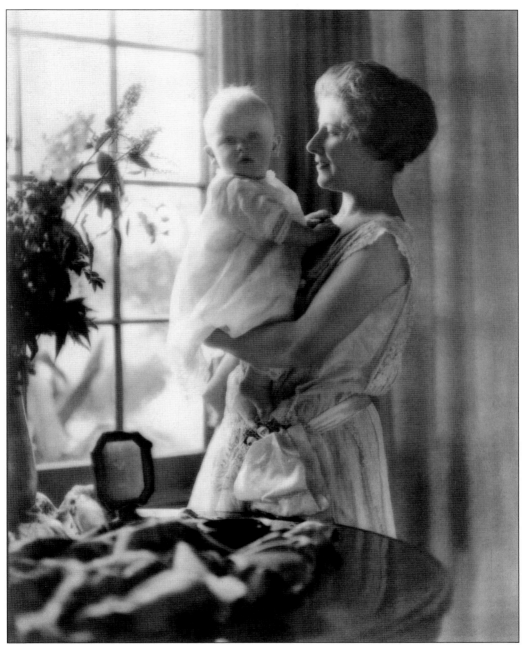

Mary Eliza Vail, Walter and Margaret's eldest daughter, is pictured holding her 12-month-old son, James Vail Wilkinson, around 1924. Mary was born in 1887 at the family's Los Angeles home in St. James Park. She was 19 years old when her father died, and she and her mother and siblings took over management of the Vail cattle business after his death. (Courtesy of Whitney Vail Wilkinson.)

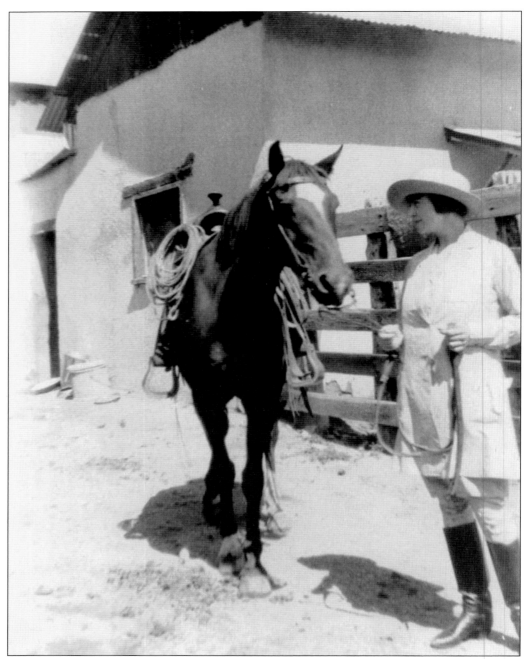

Margaret "Margie" Russell Vail, age 27, is pictured with her horse in the east corral area of the Empire Ranch House, around 1923. In 1896, the Vails established a second home in Los Angeles, where Margie, their youngest child, was born. That same year, they decided to make Los Angeles the site of corporate headquarters and their permanent home—one they agreed was more fitting than the Empire Ranch for the proper education of their seven children. The Vail children were delighted to return to their beloved Empire Ranch each summer. (Courtesy of Dusty Vail Ingram.)

Laura Perry married William Banning Vail on July 4, 1913, right after he became manager of Empire Ranch. They raised their daughter and two sons there from 1914 until 1928. Laura was a charming woman with style, who could tell stories that would mesmerize the listener. Laura loved the ranch and everything about it. Much of her time on the Empire was spent decorating and fixing things up around the Empire Ranch House. She loved flowers, gardening, and visits with friends at their home. An avid reader, she enjoyed reading the *New York Times* and book reviews. The handsome couple often socialized with other ranching families and their many friends in Tucson. Every Fourth of July, the Vails threw a big house party with spectacular fireworks to celebrate their wedding anniversary. This portrait of Laura was taken at her parents' Church Street residence in Tucson in 1920. (Courtesy of Dusty Vail Ingram.)

For Dusty Vail, growing up on the Empire Ranch with her parents, Laura and Banning, was like having two separate lives: "The ranch life had to do with the cowboys and the cattle and working them, that was my father's. Then there was the living in the house with mother, and all the things that went on in there. We accepted this as children as they do in any household. So there was a differentiation between the two." In the 1920s, the Vail family was making large investments in California. The Vails ran cattle on their landholdings there—Santa Rosa Island, Temecula Ranch, Pauba Ranch, and Santa Rosa Ranch. At one time, they leased land to run cattle on Catalina Island from Capt. William Banning, Walter Vail's good friend for whom Dusty's father was named. In this c. 1932 photograph, 18-year-old Dusty poses while visiting her Uncle Ed and Aunt Margaret at Jalama Ranch, near Lompoc, California. (Courtesy of Dusty Vail Ingram.)

Shown here is Mary Boice riding the rangeland of the Empire Ranch around 1956. Mary met Frank Boice in Pearce, Arizona. They were married in 1923 and made the West Wells property in the Sulphur Springs Valley their first home. After Frank and Mary moved to the Empire Ranch in 1928, Mary divided her time among supervising the household, overseeing the education of their two sons, and assisting her husband in the day-to-day ranching operation. Mary was an immaculate housekeeper and avid gardener. She homeschooled her sons before they attended the nearby Empire School. Mary lived with her sons in Tucson during their high school years, returning to the Empire Ranch on weekends. The Boices enjoyed entertaining at the Empire Ranch House; their annual New Year's Eve party was a major social event. (Courtesy of Katherine "Kitty" Boice Collection.)

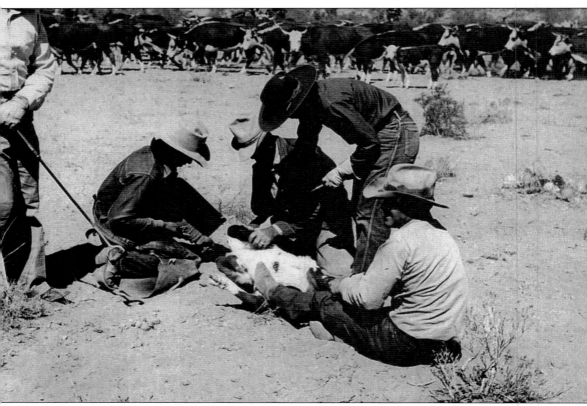

Mary Boice (black hat) is shown vaccinating a calf while unidentified ranch hands get ready to brand it in this 1940s photograph. Ranching on the Empire during the Boice era (1928–1969) was truly a family affair. Mary participated in all facets of the family cattle ranching operation with her husband, Frank, and sons, Pancho and Bob—including roundups, sorting the herd, and shipping cattle. Mary had the reputation of being a first-class ranch hand. A fellow ranch hand gave this account: "She did everything but doctor for screwworms." Jack Cooper, a wrangler who worked for Frank Boice, remarked, "But that Mary, you have to take your hat off to her. Mary could just ride Old Dutch right out there and turn them back just as good as the cowboy. Just as good as a man." (Courtesy of Ann Boice.)

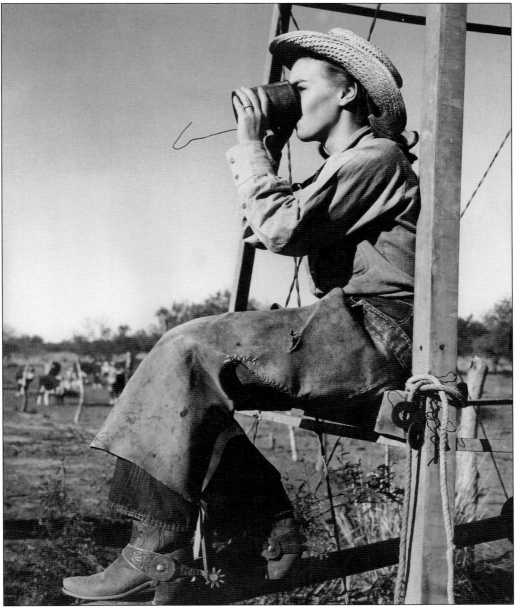

Sherry Boice is pictured taking a needed respite from ranch work in the 1940s. Sherry Genevieve Bailey was married to Frank Stephen "Pancho" Boice in 1948 by Father Perry at St. Phillip's Church in Tucson. The newlyweds moved into the Grove House, the small adobe house located northwest of the Empire Ranch House. This was their temporary residence when their son Frank Stephen "Steve" was born in 1951. Shortly after, they moved into the new, modern home built on the hill north of the original ranch house and known as the new ranch house. This was the home where their son Steve and daughters Katherine Anne, Sherry Bailey, and Carol Enid spent their childhood years. Frank and Mary, and their sons Pancho and Bob, along with their wives and children, lived and worked at Empire Ranch headquarters until Frank's death in 1956. (Courtesy of Katherine "Kitty" Boice Collection.)

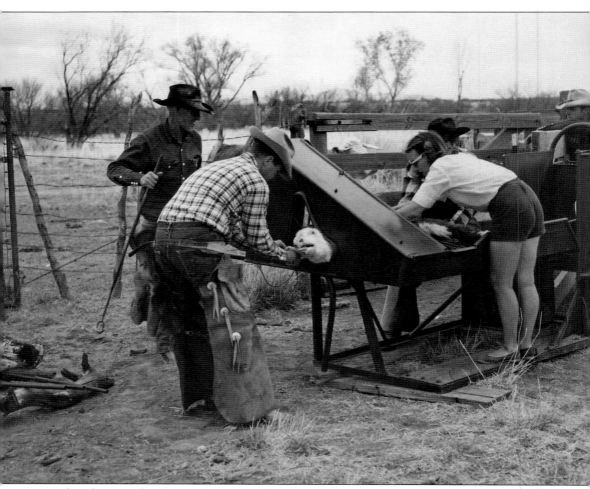

In this photograph, taken in the 1960s, Sherry Boice keeps a good hold on a calf to help Pancho Boice (left) and unidentified cowhands brand cattle in the corral. Like Mary Boice, Sherry took time from her household and child-rearing responsibilities to take part in activities on the Empire Ranch. Frank, Mary, Bob, Pancho, Sherry, and hired help worked side by side to complete jobs such as pouring cement for wells and inoculating large herds. Norman Hinman, a 22-year-old cowhand for the Boices in the summer of 1953, remembered how Sherry talked him into returning to college. One day, as she was driving him to Patagonia to see the doctor, she asked him to think about whether pursing an education "was a good thing" for him. Norman returned to school that fall and completed an undergraduate degree in animal science and biology. (Courtesy of Katherine "Kitty" Boice Collection.)

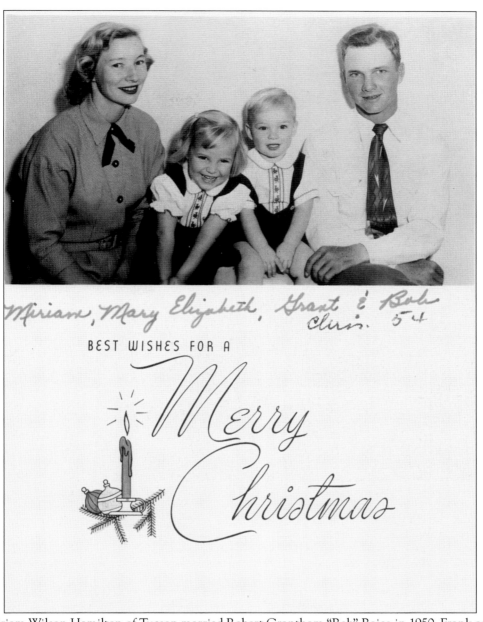

Miriam, Mary Elizabeth, Grant & Bob
Chris. 54

BEST WISHES FOR A

Merry Christmas

Miriam Wilson Hamilton of Tucson married Robert Grantham "Bob" Boice in 1950. Frank and Mary Boice purchased a small, front-gabled building with a metal roof from Fort Huachuca that was originally constructed as Army officer housing. Frank had the surplus building moved to the Empire Ranch as a home for the newlyweds. The remodeled house, now called the Huachuca House, was nicknamed "Bob's Casita." Miriam and Bob's daughter Mary Elizabeth and son Robert "Grant" were born during the time the Boices lived at Empire Ranch. In 1955, they moved to the Slash S Ranch near Globe, Arizona, which the Boice family owned and operated until 1978. In 1958, they built their own home in Globe, where they raised their children. Shown in the Boice family Christmas card from 1954 are, from left to right, Miriam, Mary Elizabeth, Grant, and Bob. (Courtesy of Frank Hedgcock.)

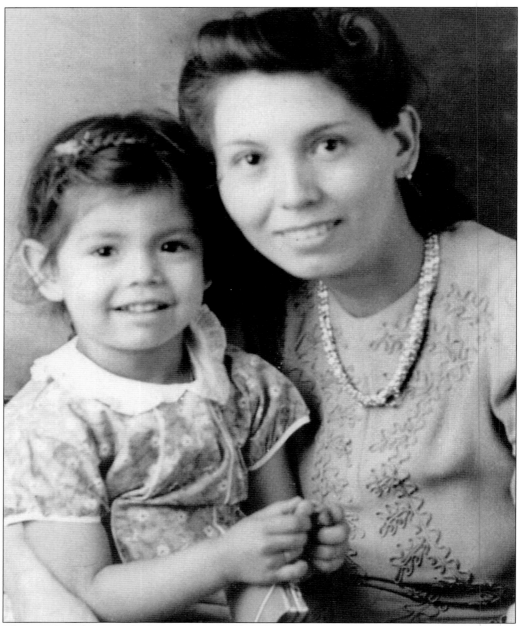

This c. 1943 photograph shows Mercy (left) and Eva Ferra Jimenez. Born in 1917 in Pantano, Arizona, Eva lived at Empire Ranch from 1927 to 1945. She was raised on the ranch by her grandparents, who worked for the Vails. They resided in a small, two-room adobe house near the Empire Ranch House that was called the hired man's house. When the Boice family purchased the Empire Ranch in 1928, they allowed Eva and her grandparents to remain there. At the age of 13, she began to help care for Mary Boice's sons, Bob and Pancho. While living and working on the Empire, Eva met cowhand Richard "Dick" Jimenez, who worked for Frank Boice from 1927 to 1945. The couple lived at the Empire Ranch with their daughter Mercy until 1945, when they moved to the Crown C Ranch in Sonoita, Arizona. (Courtesy of Mercy Jimenez Sumner.)

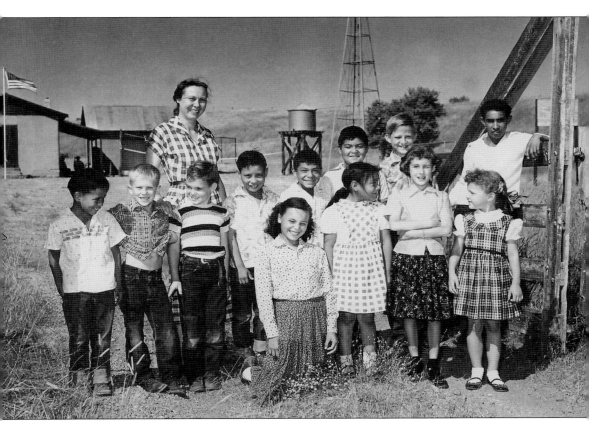

Dorothy Fisher, niece of the wife of local rancher Harold Thurber, was the teacher at the Empire School from 1954 to 1964. The school, located near the Empire Ranch, was part of the Pima County School system and was attended by children from a number of nearby ranches, including the Empire. As a young girl in the 1920s and 1930s, Eva Ferra (Jimenez) traveled each day two hours by horse with her dog, Valente, to attend the school when she lived at the Empire Ranch. Pancho and Bob Boice attended the school for a short time. Fisher taught Sherry and Pancho's children in the early 1960s. Empire School students posing with Fisher in this 1955 photograph are, from left to right, (first row) Judy Cocova, Rita Laguna, Linda Fleming, and Patty Peña; (second row) Louis Urquides, Walter Pine, David Feldman, Jesus Urquides, Richard Laguna, John Laguna, Arthur Stoddard, and Ernest Molina. (Courtesy of Katherine "Kitty" Boice Collection.)

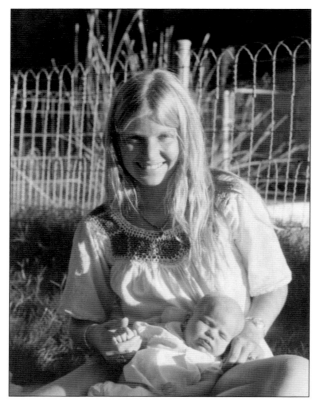

In 1972, Frank Stephen "Steve" Boice and Carol Anne "Annie" Helmericks of Tucson, Arizona, were married by the same minister, in the Episcopal church, as Steve's parents 24 years before. Initially, Steve and Annie took up residence in the new ranch house. Annie loved the Empire Ranch House, shown in the below photograph, and she and Steve eventually made it their home. She cooked, baked everything from scratch, and helped in the operation of the ranch, including mending fences, and branding, dehorning, castrating, and vaccinating cattle. Pictured at left are Annie and her infant daughter Faith in 1975. (Left, courtesy of Annie Helmericks-Louder; below, courtesy of Jean Aspen.)

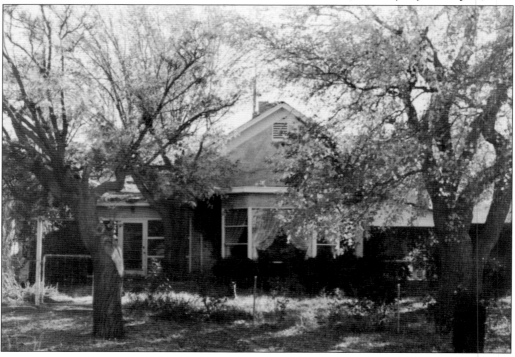

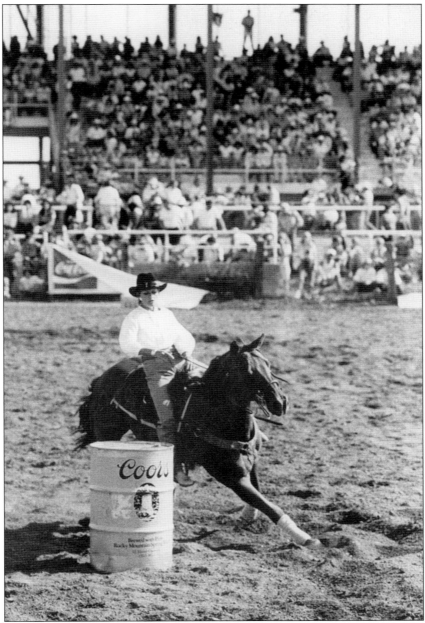

Billie Donaldson barrel races in a riding competition at the Sonoita Rodeo and Fairgrounds in 2006. Billie Parten met Macfarland "Mac" Donaldson through mutual friends while working as a veterinary technician. In 1977, they married and lived on the family ranch outside of Tucson, raising horses with Mac's brother. From 1978 to 2009, they partnered with Mac's father, John Donaldson, in running cattle on the Empire. For the first six years, they lived at the Cienega Ranch with their three children. Later, they moved to the new ranch house at Empire Ranch headquarters, living there for three years. On the occasions Billie had childcare, she helped Mac and her father-in-law with moving cattle to the different pastures. Donaldson, a self-described "isolated ranch woman," learned to adapt to life on the Empire Ranch. (Courtesy of the Donaldson family.)

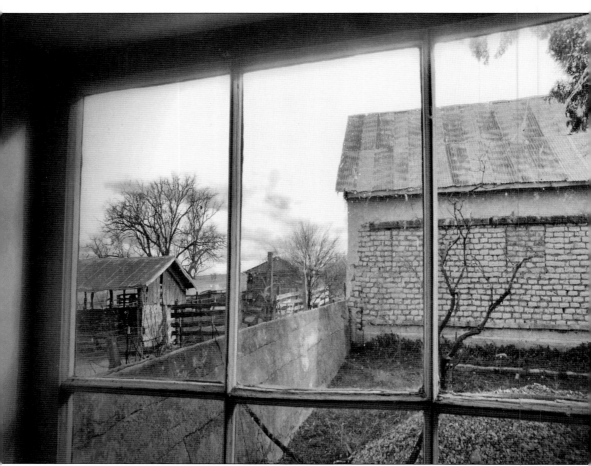

This photograph by Southwestern photographer Murray Bolesta is titled *Ghost Ranch 2*. The image shows the view of the adobe hay barn seen through the window of the south bedroom in the children's addition of the Empire Ranch House. The beautiful garden that once was abundant with irises, vegetables, green grass, and flowering vines on the stone wall is no longer. What remains, invisible to the eye, is the spirit of the "heart and hearth" of this special place for the families who once lived here. The Empire Ranch House stands as a tribute to the women of the Empire—Margaret, Laura, Mary, Sherry, Miriam, Annie, Billie, their daughters, and others, such as Eva and Dorothy, who encouraged the Vail, Boice, and Donaldson children. The rich legacy of these courageous women reverberates today through the contemporary women of the Empire Ranch—Kristin Tomlinson and her two young daughters. (Courtesy of Murray Bolesta/ CactusHuggers Photography.)

Four

GROWING UP ON THE EMPIRE RANCH

I didn't like the "Mary Jane" shoes and wearing dresses and things like that bothered me. Finally, I was allowed to wear blue jeans. For many years I had to wear bloomers, and I hated that. Finally, though, I got my own saddle. I was liberated from skirts—bloomers, rather—and I finally got to wear blue jeans and "broken-in" chaps.

—Laura Perry "Dusty" Vail

Children growing up on the Empire spent much of their time outdoors, with the freedom to explore and have grand adventures in the countryside and inside the ranch buildings. They used their imaginations to make their own fun. Many of the children helped out with ranch work, learning horseback riding, roping, and other cowhand skills. Favorite activities were riding horses, riding bikes, playing the piano, playing marbles, digging in the dirt, swimming, exploring along the creek, and reading. For companions, they had their horses and dogs. For playmates, the children of the owners, cowhands, and ranch workers had each other.

Six of Walter and Margaret Vail's seven children were raised on the Empire—Nathan Russell, Walter Lennox Jr., Mary Eliza, William Banning, Mahlon, and Edward Newhall. Margaret Russell was born after the family moved to California. Banning and his wife, Laura Perry, raised their three children on the Empire—Laura Perry "Dusty"; William Banning "Bill"; and Thomas Edward "Tom."

During the Boice era, Frank and Mary raised sons Bob and Pancho on the Empire. Two of Bob and Miriam's four children, Mary Elizabeth and Grant, were born while they lived here. Pancho and his wife, Sherry, raised Steve, Katherine "Kitty," Sherry, and Carol here. Steve and Annie Boice's daughter, Faith, started her life on the Empire.

Mac and Billie Donaldson's three children—Alexa, Sam, and Renée—grew up on the Empire. Sam helped run the ranch as an adult, and his and wife Jennifer's son, Colton, and daughter, Mackenzie, spent their early childhoods here.

The laughter, learning, and joy of children on the Empire continue today during the events and workshops the Empire Ranch Foundation offers to the children of the area.

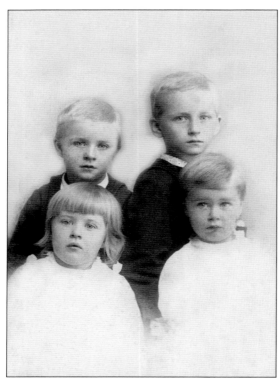

Walter and Margaret Vail's eldest sons and daughter are shown in this c. 1892 studio photograph. Shown are, from left to right, (first row) Mary Eliza and William Banning; (second row) Walter Lennox Jr. and Nathan Russell. Six of the Vails' seven children were raised on the Empire Ranch until the family moved to Los Angeles in 1896. (Courtesy of Dusty Vail Ingram.)

Shown here are, from left to right, Nathan Russell, William Banning, Mary Eliza, and Walter Lennox Vail Jr., posing with the family's dogs around 1890. The Vail children as adults were active participants in the Vail cattle business. When their father, Walter, died in 1906, his estate was divided between his wife, Margaret, who received half, and their seven children, who each received one-fourteenth. (Courtesy of Whitney Vail Wilkinson.)

The first of Walter and Margaret Vail's children, Nathan Russell (shown here in 1884), was named for Walter's uncle, Nathan Randolph Vail, a wealthy businessman who encouraged his nephew to look into the cattle ranching business in southern Arizona. Nathan arranged for Walter to meet several prospective partners for the venture and loaned him money. (Courtesy of Whitney Vail Wilkinson.)

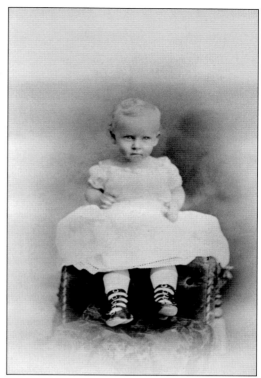

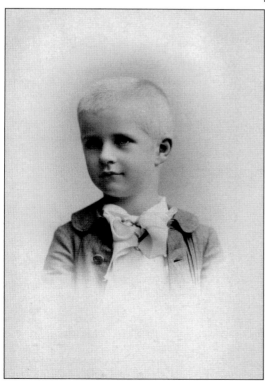

Walter Lennox Vail Jr., born in 1885 and shown here at age five, was the second of Walter and Margaret Vail's children. He handled all livestock and supplies acquisitions as the corporate purchasing agent for the Vail cattle business in Arizona and California after his father's death in 1906. (Courtesy of Whitney Vail Wilkinson.)

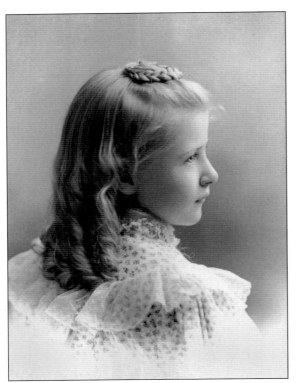

Mary Eliza Vail is shown here at approximately nine years of age in 1896. Mary, along with her elder brother Nathan Russell and their mother Margaret, formed the board of directors for the Empire Land and Cattle Co. and maintained full managerial control over corporate decisions after the death of Walter Vail in 1906. (Courtesy of Whitney Vail Wilkinson.)

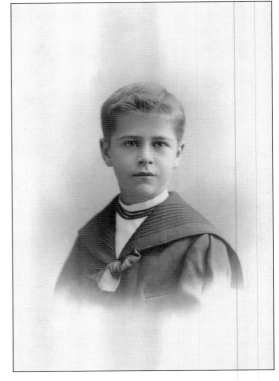

William Banning Vail, the third-eldest of Walter and Margaret Vail's sons, appears in this 1897 studio portrait at eight years of age. Upon his father's death in 1906, Banning became superintendent for all Arizona property. He came back to the Empire Ranch in 1907 at 17 years of age to learn the cattle ranching business and took over as ranch foreman in 1913. (Courtesy of Whitney Vail Wilkinson.)

Nathan Russell, age four, and Walter Lennox Vail Jr., age two, pose in their finery for the camera in this 1888 studio photograph. Continuing the Vail cattle legacy, Nathan's son, Nathan Russell Jr., was a partner in the Vail cattle enterprises in California, and his grandson Tim serves on the board of directors for the Empire Ranch Foundation. (Courtesy of Whitney Vail Wilkinson.)

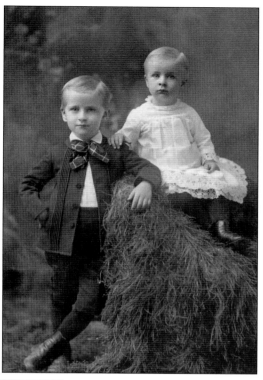

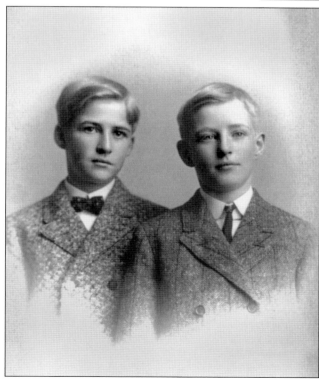

Mahlon (left), the fifth child of Walter and Margaret Vail, and Edward Newhall, their sixth child, pose at ages 15 and 13, respectively, in 1905. Mahlon took over as foreman and superintendent of the Pauba Ranch in California upon Walter's death, while Edward helped manage the Vail family's Santa Rosa Island, California, ranch and managed the Jalama Ranch near Lompoc, California. (Courtesy of Whitney Vail Wilkinson.)

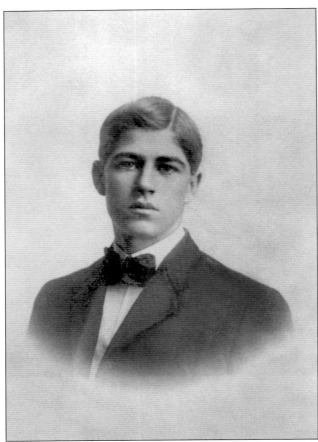

William Banning Vail is shown in this studio portrait around 1910, when he was 21 years of age. Banning returned to the Empire in 1907 from the Vail family's home in California, eventually taking over as the Empire Ranch manager. He and his family moved back to California in 1928 and helped operate the Pauba Ranch and later the Santa Rosa Island Ranch. (Courtesy of Dusty Vail Ingram.)

"Brother" Brown (left) and Dusty Vail play with their bikes in 1918. Brother was the son of the Vail family cook, Lena Brown. He and Dusty, daughter of Banning and Laura Perry Vail, became close friends and playmates, keeping each other company and having fun together out on the isolated Empire. (Courtesy of Dusty Vail Ingram.)

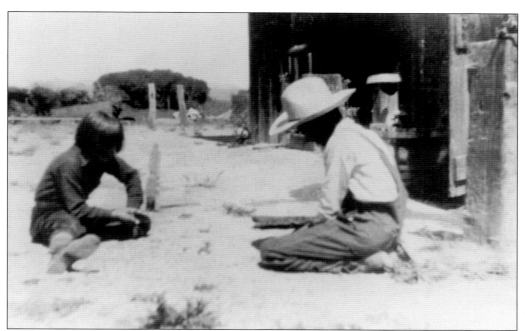

The ranch owners' children and the ranch workers' children were playmates and friends. In this c. 1924 photograph, Dusty Vail (left) plays marbles with her close friend Michael "Mikey" Estrada, the eldest son of Empire ranch hand Bartolo and his wife, Rita. Playing marbles was a favorite pastime of many of the Vail children. (Courtesy of Dusty Vail Ingram.)

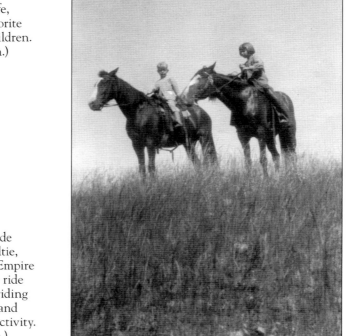

Banning and Laura Perry Vail's children Bill (left) and Dusty ride their horses, Dynamite and Coltie, out on the range in 1923. The Empire Ranch children learned how to ride at an early age, and horseback riding through the ranch's grasslands and along the creek was a favorite activity. (Courtesy of Dusty Vail Ingram.)

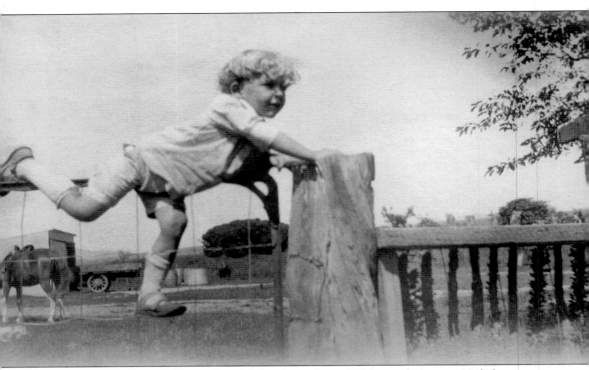

Tom, son of Banning and Laura Perry Vail and grandson of Walter and Margaret Vail, demonstrates his skill in getting around the ranch and going over the yard fence in this photograph from around 1922, when he was four years of age. In the background is the garage for the ranch. The children of the Empire lived an active, outdoors life and spent much of their time playing around the ranch buildings. Tom and his siblings, Dusty and Bill, were born while the family lived on the Empire, and they spent much of their childhoods there. They lived in the children's addition of the Empire Ranch House, built around 1886 for their father and his siblings. In the 1920s, some of the ranch house's original wooden floors were replaced by concrete to prevent skunks from nesting under the floors. Also, the open wood-frame porch was enclosed as a screened porch, known as an "Arizona Room." These screened porches were common in Arizona before air-conditioning, providing a cooler place to sleep during the hot summer nights. (Courtesy of Dusty Vail Ingram.)

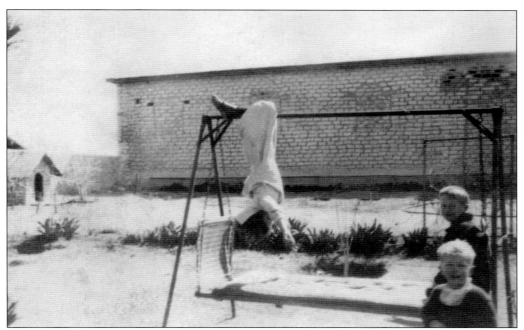

Dusty Vail (hanging by her feet and wearing the hated bloomers) and her brothers Tom (top) and Bill are having fun on their swing in the Empire Ranch House yard in 1923. The children of the Empire had to use their imaginations to invent games and create fun for themselves, which included playing pranks on each other. (Courtesy of Dusty Vail Ingram.)

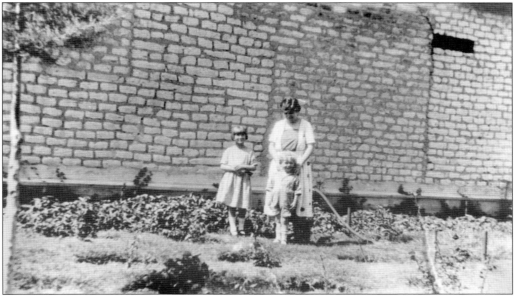

Dusty (left) and Tom pose with their mother, Laura Perry Vail, at the Empire Ranch headquarters in 1923. According to Dusty, she acquired her nickname because "for the first three days after I was born, every time [my dad] came to look at me, they were giving me something to drink. He automatically said, 'My, she must have a dusty throat,' thinking of driving cattle." (Courtesy of Dusty Vail Ingram.)

Dusty Vail is outfitted in cowhand gear for riding in 1926. Dusty loved to be part of the cattle ranching life, helping out her dad, Banning, and the Empire Ranch cowhands with the horses and the cattle. She rode with the cattle herd when it was moved down to Sonora, Mexico, in the mid-1920s to avoid the drought. (Courtesy of Dusty Vail Ingram.)

Dusty Vail (right) is saddled up to ride in the Empire Ranch headquarters corral in 1924. On the left is Empire Ranch foreman Haydon Hunt. Dusty loved to ride and participate in the running of the ranch. The cowboys' saddle rack is shown on the left. (Courtesy of Dusty Vail Ingram.)

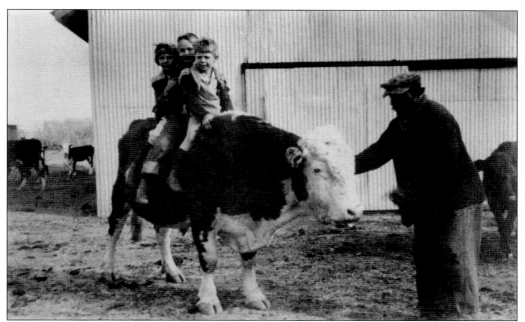

The ranch children learned to ride horses, but in this 1920 photograph, some of the young ones are trying out the view from on top of a ranch bull. From left to right, Dusty Vail, playmate Bill Blenman (a friend from Tucson), and Bill Vail hang on to Jerry Bull. They are watched over by ranch hand Apache Joe. (Courtesy of Dusty Vail Ingram.)

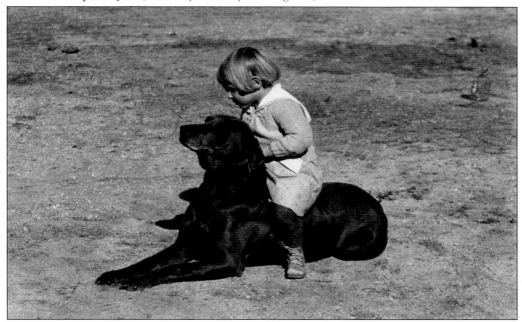

The children of the Empire Ranch often had dogs as family pets. Here, Dusty Vail sits astride the family dog in 1918—perhaps in preparation for learning to ride a horse. Pets offered protection and companionship to the children as they played and explored the ranch. (Courtesy of Dusty Vail Ingram.)

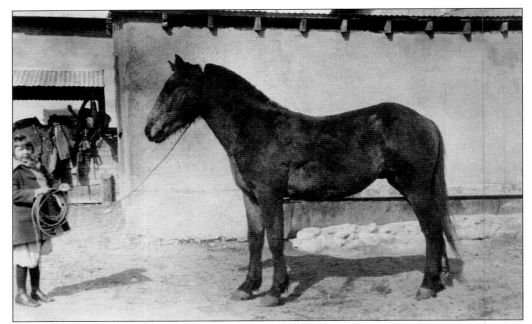

Dusty Vail holds Tortuga in front of the foreman's quarters at the Empire Ranch headquarters in 1920. The Empire Ranch children learned to ride and take care of the ranch's horses at a young age, and they spent many hours with these horses. *Tortuga* is the Spanish word for turtle or tortoise, a fitting name for a horse calm enough for children. (Courtesy of Dusty Vail Ingram.)

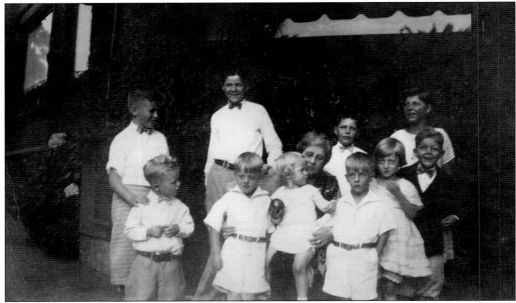

In 1925, Margaret "Nana" Vail is enjoying the company of her grandchildren. They are, from left to right, (front row) Sandy, Russ, Mary, Al, Margaret, and Tom, sporting a black eye; (back row) Buzzie, Granville, Bill, and Dusty. Nana was always loving and caring with her grandchildren, and she delighted in telling them stories about the Empire Ranch. She would often read to them when they visited, just as she had done with her own children. (Courtesy of Dusty Vail Ingram.)

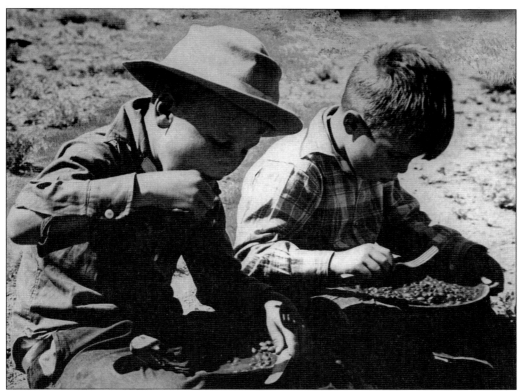

Bob Boice (left) and his cousin Fred Boice, the son of Henry and Margaret, eat beans on an Empire Ranch roundup around 1937. During roundups, the cowhands were fed well with meals of beans, beef, and biscuits. As cowhand Gerald Korte (1946–1949) put it, "Those roundup cooks were the best." An oft-told tale is that Bob wanted to be a roundup cook when he grew up. (Courtesy of Ann Boice.)

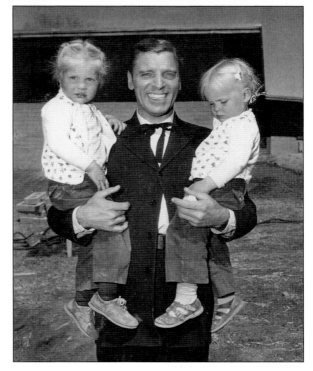

During the 1940s and 1950s, many Hollywood films were shot at the Empire Ranch and the nearby ranching communities. Actor Burt Lancaster poses here with Pancho Boice's children Katherine "Kitty" (left) and Sherry in 1955 during the filming of *Gunfight at the O.K. Corral*. The Boice family enjoyed being "on the set" to watch westerns being made. (Courtesy of Katherine "Kitty" Boice Collection.)

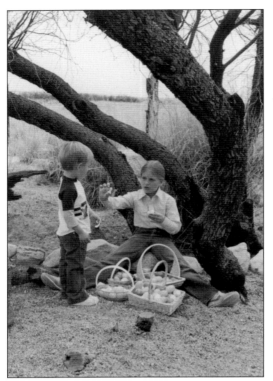

Sam and Alexa Donaldson, children of Mac and Billie, hunt for Easter eggs among the grasslands and trees of the ranch property in 1980. Alexa was five and Sam was four months old when the family started ranching on the Empire. The children did most of their schooling in Vail, Arizona, an 84-mile round-trip each day from the ranch to the bus stop. (Courtesy of the Donaldson family.)

Renée Donaldson, the youngest child of Mac and Billie, smiles at her dad while riding around the ranch in his truck in 1984. Renée was born on the Cienega Ranch and grew up helping out with the ranching duties on the Empire and owning some of the cattle in the herd. (Courtesy of the Donaldson family.)

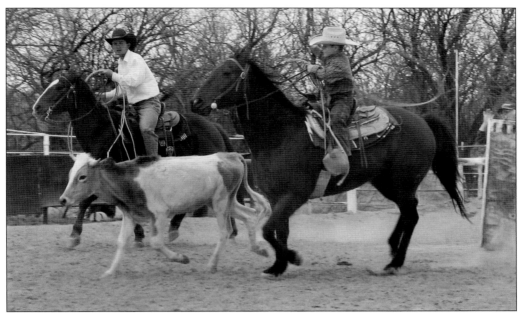

Sam Donaldson (left) and his son Colton rope a steer in 2006. Sam, the son of Mac and Billie, grew up on the Empire. As an adult, he became a partner in the running of the Empire during the Donaldson era and passed his ranching knowledge down to Colton and daughter Mackenzie, both of whom participated in junior rodeo. (Courtesy of the Donaldson family.)

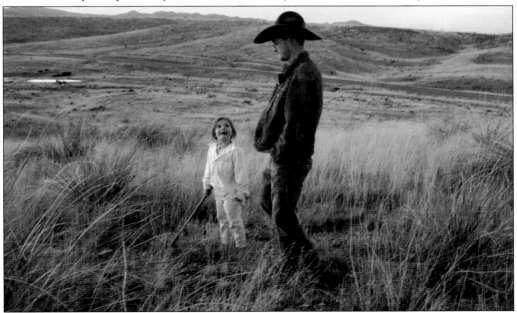

Sam Donaldson walks the Empire Ranch range with his daughter Mackenzie in 2006. Sam and his wife, Jennifer, became Empire Ranch, LLC, ranching partners in 2003, and they and their two children, Mackenzie and Colton, were active participants in the Empire Ranch life. Sam's dad, Mac, never pushed him toward the ranching life, and Sam is taking his dad's cue in raising his own children. (Courtesy of the Donaldson family.)

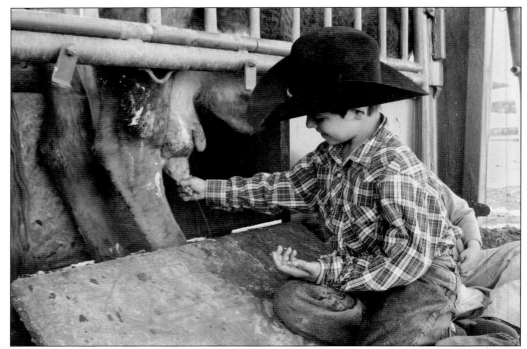

Colton Donaldson demonstrates his way with cows as he milks one in 2006. Colton was the fourth generation of Donaldsons involved in the cattle ranching legacy at the Empire Ranch. His great-grandfather John, grandfather Mac, and father, Sam, ranched on the Empire from 1975 to 2009. Sam now works on a nearby ranch north of Sonoita. (Courtesy of the Donaldson family.)

Andrew Barker, son of Amy Barker and cowhand Tom Barker of Sonoita, teaches roping to an unidentified participant in the Family Fun Day at the Empire Ranch in August 2011. The Empire Ranch Foundation continues to share the cattle ranching heritage with the children of the area through workshops and family-friendly events. Andrew learned his roping skills by helping rancher Mac Donaldson herd up cattle on the Empire Ranch. (Courtesy of Cheryl Rogos.)

Five

RANCHING WAYS AND COWHAND TRADITIONS

Many went by names other than their own. There'd be Slim, Fat, Will, and Jim. It drove cattlemen crazy trying to keep track of these guys. You'd ask them what their other name was, and they'd say, "That's all I've got. Isn't one name enough?"

—Harry Heffner, Empire Ranch foreman during the Vail era

The cowhands of the Empire Ranch play a vital role in the running of the ranch. Without them, the ranch would not have survived and prospered. Some of the Empire cowhands were members of the families who ran the ranch—the Vails, the Boices, and the Donaldsons. Others were outsiders who became part of the Empire Ranch family.

A cowhand's life is a busy one, filled with hard work and unpredictable circumstances. Long days and nights, ornery cattle, time spent away from home and families, spooked horses, wild animals, and fickle weather are common occurrences. In southern Arizona, cowhands also deal with prickly cacti and drought. But the cowhand's life is also one filled with the joy of working outside and the camaraderie of working as a team to get the job done.

Cowhands must be independent, innovative, self-sufficient, courageous, and strong. Their duties are many. They doctor animals, shoe horses, mend fences, keep water supply equipment in working order, and brand cattle. They are experts in handling horses and in roping.

Every ranch has its own cowhands, but during roundups or other times when extra hands are needed, cattle ranches share cowhands. During roundups, they brand, vaccinate, earmark, dehorn, treat, and castrate cattle.

The Vail family used mainly vaqueros from southern Arizona. When the Boice family took over operation of the ranch in 1928, they employed mostly cowhands who used Texas ranching practices. Father John, son Mac, and grandson Sam Donaldson did most of the ranch work during the Donaldson era on the Empire, hiring extra cowhands as needed. Today, Ian Tomlinson runs the Empire with the help of one cowhand, hiring a crew of eight to help out during the roundups.

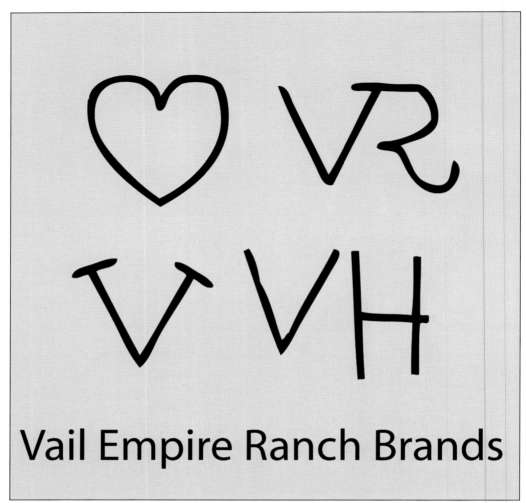

Vail Empire Ranch Brands

Cattle raised in the open range of the American West mingle with cattle from other ranches, so brands and earmarks are used to identify their owners. These marks are recorded by the state government and published in livestock brand books. In addition to serving a practical purpose, brands are highly personal. They represent the ranch, its workers, and its traditions, and the particular style of a brand reflects the values and personalities of the owners. The Vails (1876–1928) used the heart and V brands to mark their cattle as part of the Empire Land and Cattle Co. They used the VR brand on cattle to indicate the partnership of Vail and Risley, and the VH brand to mark the Empire Land and Cattle Co. horses. Brands were placed on the left hips or left ribs of the cattle and the left hips of the horses.

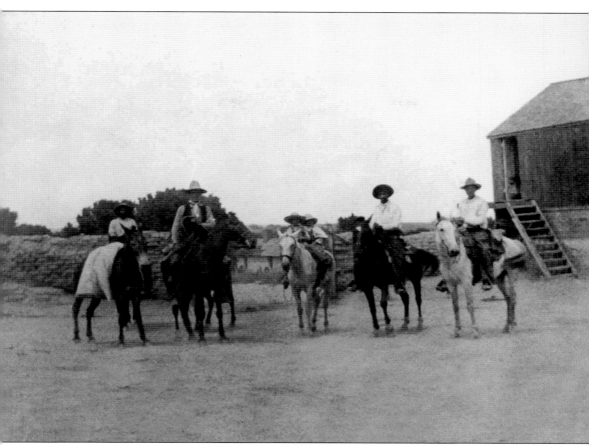

Cowhands and children mount up in the early 1900s in front of the adobe-wall corral attached to the Empire Ranch headquarters. The cowhands' bunkhouse, which later burned down, is shown in the background. The children and the cowhands wear long-sleeved shirts and broad-brimmed hats to protect themselves from the sun and from the thorns on the native trees, bushes, and cacti. The bandana around the neck of the second individual from the left would have been used as a mask against the dirt kicked up by cattle, as a shield against the burning of the sun on his neck, as an insulator for hot pots or branding irons, and as a sling in case of injury. A pack mule accompanies the group. Mules, offspring of male donkeys and female horses, were widely used on ranches in the West to carry supplies. A mule is stronger and requires less food than a horse of similar size, and a mule possesses great endurance and an independent spirit. (Courtesy of BLM.)

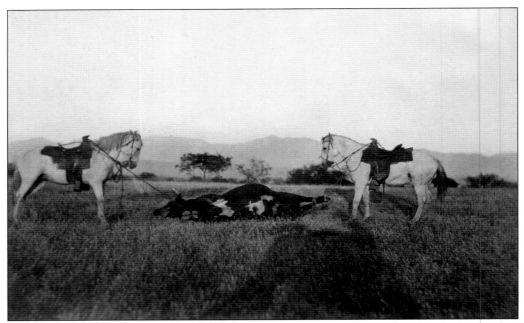

This photograph from the 1890s is labeled "cow ponies holding bull." The engraved letterhead of the Empire Land and Cattle Co. was based on this photograph. Horses are holding down a bull using reatas (rawhide ropes). The art of making reatas is an ancient one, widely used on the cattle ranches to restrain animals. (Courtesy of Dusty Vail Ingram.)

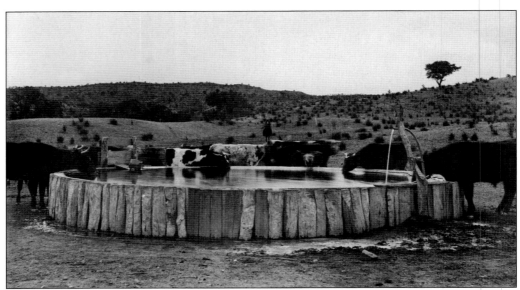

Empire cattle drink from a water tank in the 1890s. Water is a precious commodity in the desert, and much of the time and effort of the ranch owners and cowhands were spent making sure that water supplies were adequate for the cattle. Arizona has experienced periodic droughts, including severe ones in the early 1890s and the 1920s. (Courtesy of Dusty Vail Ingram.)

Good horses are vital to successful cattle ranching enterprises. The Vails raised their own horses, bringing in stallions from California and Hamiltonians, a standard breed horse. Walter Vail gave his best men the responsibility of training the ranch's horses. Empire Ranch foreman Harry Heffner stated, "The horse from his withers forward belonged to Vail; the other part belonged to the cowboy." (Courtesy of Dusty Vail Ingram.)

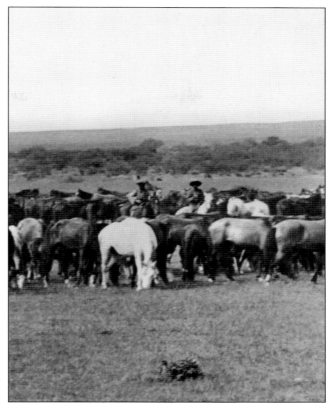

Hadden V. McFaddin became Empire Ranch foreman in 1896. His expertise in running the ranch and assisting Walter and Edward Vail helped turn the ranch into a cattle ranching empire. In this c. 1900 photograph, McFaddin is on horseback in the Empire Ranch House corral in front of the cowhands' bunkhouse. (Courtesy of George McFaddin.)

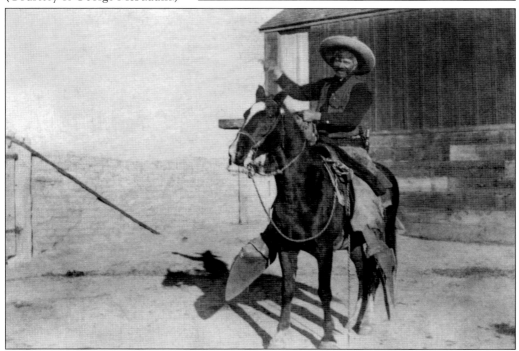

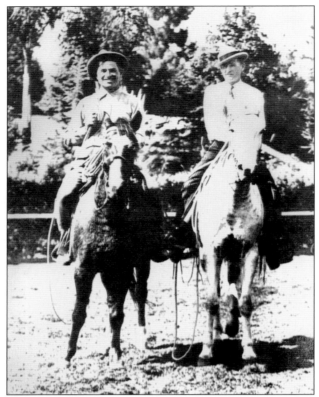

Edward Newhall Vail (right), youngest son of Margaret and Walter, poses with Will Rogers. Edward, a lifelong rancher, worked on the Vail family's California ranches, and traveled often to the Empire as a cattle buyer for the Vail Co. His daughter Susan recalls that her father "greatly admired his father and aspired to be as talented a cattleman and businessman as his father was." (Courtesy of Susan Vail Hoffman Collection.)

Cattle were driven to the nearest rail stop, held in chutes, and then shipped by train. In 1890, to protest the Southern Pacific Railroad's high freight rates, Edward Vail, foreman Tom Turner, and eight cowhands drove 900 cattle across the desert, from the Empire to California. Because of the success of this drive, the railroad rescinded its rate increase. (Courtesy of Dusty Vail Ingram.)

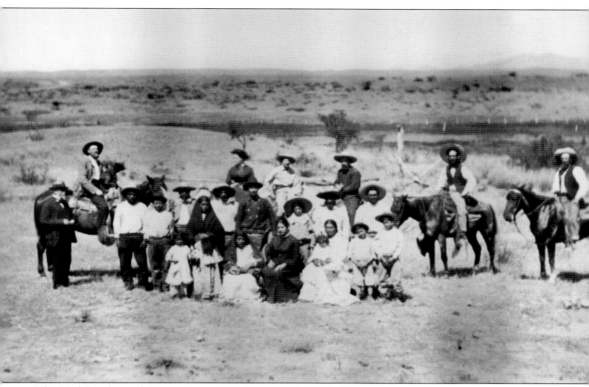

The Vail family used Hispanic vaqueros from southern Arizona on the Empire Ranch. A vaquero (va' kero), deriving from *vaca*, or "cow" in Spanish, is a herder of cattle. These cowhands used traditions and methods derived from the Spanish influence in the states bordering Mexico. Here, a group of vaqueros poses with their wives and children. According to the Empire Land and Cattle Co. ledgers from 1894 to 1896, the average pay for a vaquero was $20 a month. Experienced men, such as Blas Lopez, earned $25 a month. Empire Ranch foremen, such as Harry Heffner, earned $40 a month. Room and board were provided, with cowhands sharing quarters in the Empire Ranch House. The foremen had private quarters in the house. Meals were cooked and served in the house's cowboy kitchen and dining room. The Vails maintained a company store, where they sold such items as tinned fruits, candy, tobacco, and cigarette papers to their cowhands. (Courtesy of Whitney Vail Wilkinson.)

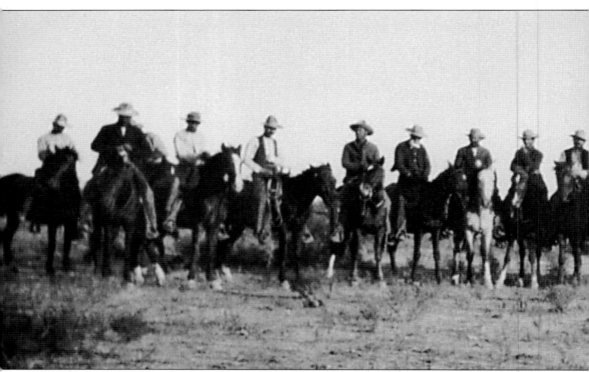

This Empire Ranch roundup photograph dates from around 1900. Roundups were held in the fall and spring, and ranchers from neighboring ranches would share cowhands and employ extra help during these busy times. To protect themselves from the sun, vegetation, and cattle, cowhands wore broad-brimmed hats, long-sleeved shirts, and leather boots. They worked from sunup to sundown, seven days a week. Their day began with a huge breakfast. They then headed out on their horses to gather, castrate, dehorn, doctor, and brand the cattle. They rotated their horses

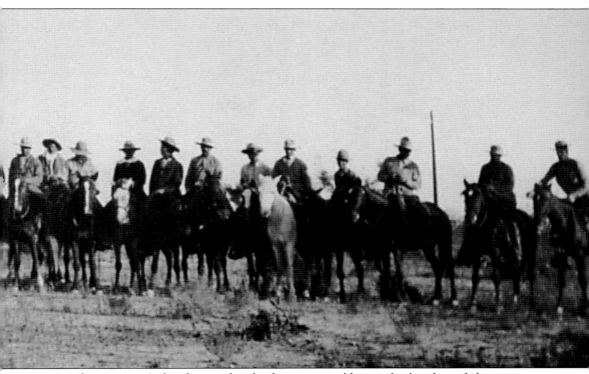

to give them a rest. At lunchtime, the chuck wagon would serve food such as chile con carne, beans, and tortillas. Supper was served after dark most days. Neighboring ranchers would agree on a common date to drive all the cattle in the area to the railroad for shipping. (Courtesy of Margaret Vail Woolley.)

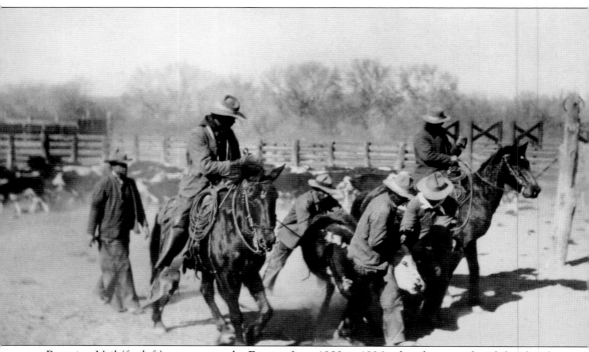

Banning Vail (far left) grew up on the Empire from 1889 to 1896, when he moved with his family to California. After the death of his father, Walter, in 1906, Banning came back to the Empire in 1907 to learn the cattle ranching business. He managed the Empire Ranch from 1912 to 1928. He and Laura Perry of Tucson married in 1913, and they raised their three children—Dusty, Tom, and Bill—at the Empire. In 1925, Banning applied to the government remount for thoroughbred stallions in order to raise horses on the Empire suitable as polo ponies. Banning battled drought in the 1920s, forcing him to sell stock and move cattle. Dusty recalls a cattle drive during this time: "Vail Co. sold what stock they could, moved some to the ranches in California, then they moved cattle down to Sonora. All the cowboys—there were worlds of cowboys—they were all involved. They were moving this whole bunch." The family moved to Los Angeles in 1928, and Banning continued to be involved in the Vail family cattle business. (In memory of William "Bill" and Evelyn Vail.)

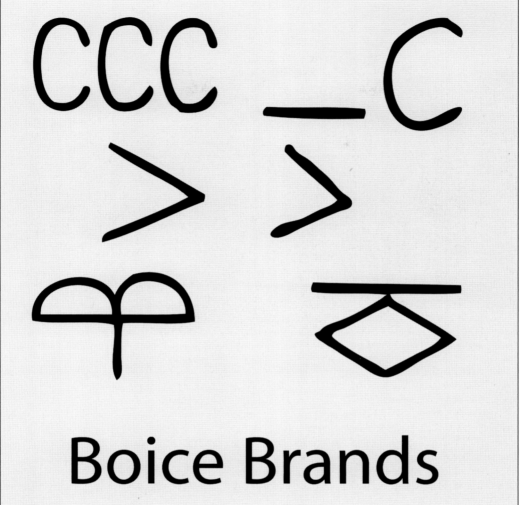

Boice Brands

Brothers Henry, Frank, and Charles Boice, partners in the Chiricahua Ranches Company, purchased the Empire Ranch from the Vail family in 1928. The Boices were well-respected cattlemen, with a long tradition of cattle ranching and ranches throughout the Midwest, South, and West. The CCC brand seen here represented the Chiricahua Cattle Co., and this brand was used on the Empire's commercial cattle herd. The C brand (top right) was used on the purebred herd and the Empire horses. The other brands were used to mark purebred bulls before they were sold or put in the commercial herd. The Boices used Anglo American Texas cowboy traditions to handle the Empire cattle and horses. The average roundup crew during the Boice era on the Empire was 16–19 men. To avoid overgrazing, the Boices kept the cattle widely distributed over the range. After the roundup crew gathered and branded the cattle, according to Boice cowboy Gerald Korte, the livestock were moved on their own legs, without trucks or trailers.

The north corral at the Empire Ranch headquarters held a saddle rack for the saddles, bridles, and blankets of the cowhands. The Vails added the roof around 1920 to protect the gear from the wind and rain. The saddle rack was used throughout the Boice era, but it was removed sometime in the 1970s. (Courtesy of Katherine "Kitty" Boice Collection.)

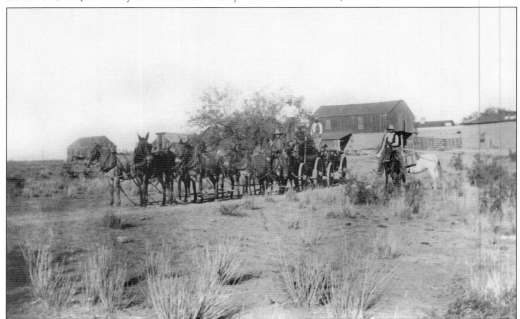

Cowhands drive a supply wagon heading east. Teams of horses and mules hauled food, equipment, clothing, building materials, and people throughout the settling of the American West. The two-story bunkhouse is shown just behind the rear of the wagon, with the adobe Empire Ranch House to the right. (Courtesy of Katherine "Kitty" Boice Collection.)

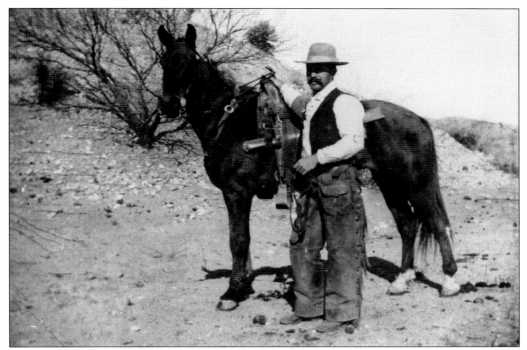

Harry Heffner hired on with Walter Vail in 1893, and he was the Empire Ranch foreman from 1902 through 1905. Under Vail's ownership and Heffner's management, the Empire grew to become a highly successful cattle ranch. Heffner also worked for the Vails at their Pauba Ranch in California and at several other Vail ranches until 1910. (Courtesy of Katherine "Kitty" Boice Collection.)

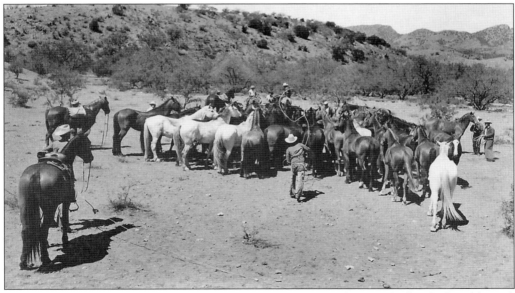

The Empire Ranch cowhands are selecting their mounts from the remuda (herd of workhorses) at the Lower Roosevelt pasture in preparation for a roundup in the 1940s. In the center of the photograph, Empire Ranch owner Frank Boice is throwing a rope to lasso his chosen mount. (Courtesy of Katherine "Kitty" Boice Collection.)

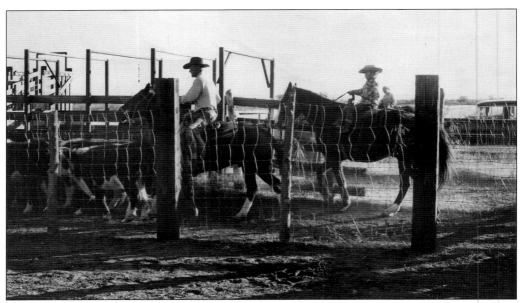

In this 1950s photograph, cattle inspector Blaine Lewis rides through the cattle chutes to check out the Empire Ranch herd. Cattle inspectors are responsible for verifying brands and ensuring that the cattle are healthy. Katherine "Kitty" Boice, daughter of ranch owners Pancho and Sherry, rides alongside on her horse Dollar. (Courtesy of Katherine "Kitty" Boice Collection.)

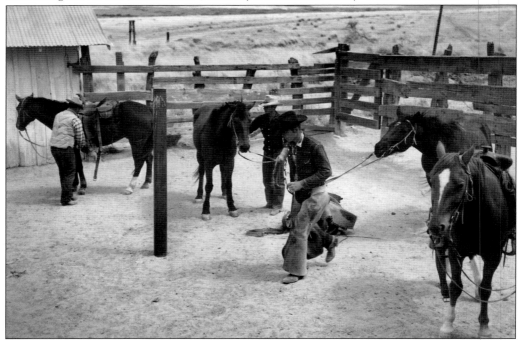

Cowhands are shown here working with horses in the Empire Ranch breaking corral. High-quality horses and cowhands with horse-handling skills are vital to the success of any ranch. Each Empire Ranch cowhand had three to five horses that he used, rotating them so that they could rest between work sessions. (Courtesy of Katherine "Kitty" Boice Collection.)

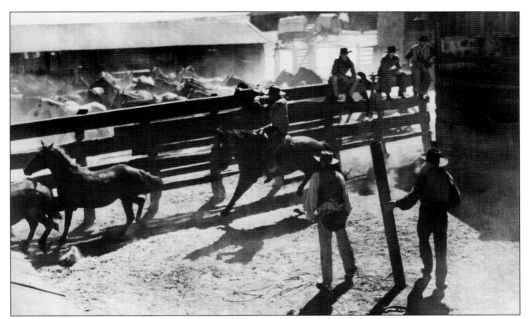

The Empire Ranch cowhands work with the Empire horses in the south corral and breaking corral during the filming of *Red River* in the 1940s. The ranch had a large herd of horses, each with its own personality and strengths. Cowhands were able to choose their own mounts. (Courtesy of Katherine "Kitty" Boice Collection.)

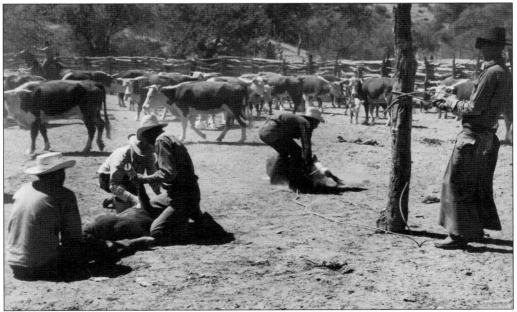

Branding of the Empire cattle herd was done at temporary camps during the fall and spring roundups. Cattle were rounded up, separated, branded, earmarked, dehorned, and treated for diseases. This roundup took place during the 1940s, when the Boice family ran the Empire, which had roundup camps at Andrade and Rosemont, among other locations. (Courtesy of Katherine "Kitty" Boice Collection.)

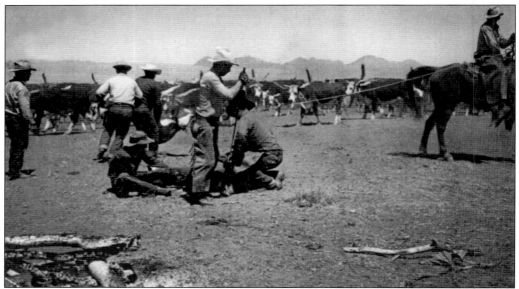

This 1930s photograph of a roundup shows, from left to right, Frank Boice, Pancho Boice, cowhand Manuel ?, an unidentified cowhand, cowhand Bob Haverty, an unidentified cowhand, and Bob Boice (on horseback) working with the Empire Ranch cattle. Roundups were cooperative affairs in which neighboring ranchers and cowhands worked together to gather, sort, and treat cattle. (Courtesy of Katherine "Kitty" Boice Collection.)

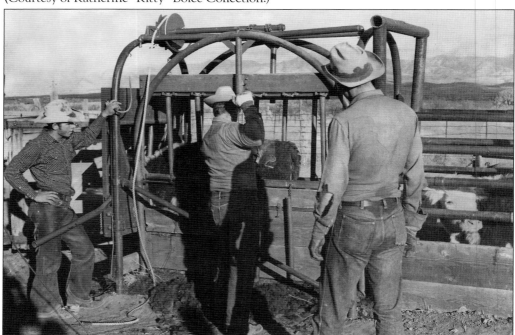

The Boice family members were experienced cattle ranchers, known throughout the Midwest and the West in the early and middle part of the 20th century for promoting the Hereford breed of cattle. In this 1950s photograph, Pancho Boice (center) brands a cow in the cattle chute in the corrals east of the Empire Ranch House. (Courtesy of Katherine "Kitty" Boice Collection.)

The cowboys' kitchen is on the left side in this photograph, with the door open. The dinner bell above the doorway called the cowhands to chow. Shown are, from left to right, Henry Boice (Empire Ranch co-owner), Ruby Barnett (wife of foreman Fred Barnett), Sherry Boice (wife of Pancho Boice), her daughters Katherine "Kitty" and Sherry, and an unidentified cowhand. (Courtesy of Katherine "Kitty" Boice Collection.)

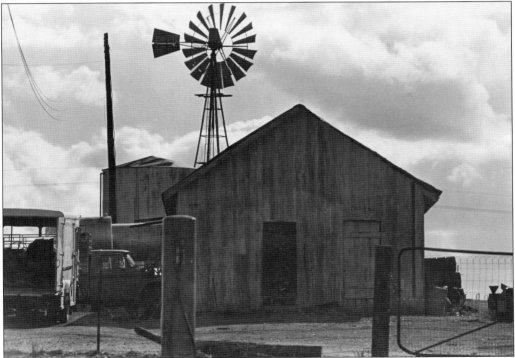

The south barn was built by Banning Vail around 1920 for horses and storage. The south end of the building housed a blacksmith and repair shop. The room at the north end was enclosed to be a movie set for one of the Westerns filmed at the ranch in the 1940s. (Courtesy of Katherine "Kitty" Boice Collection.)

Donaldson Brands

John Donaldson and his son Macfarland "Mac" took over management of the Empire in 1975 under a leasing agreement with the Anamax Mining Co., which had bought the Empire from the Gulf America Corporation. They continued ranching on the Empire under lease agreements with the Bureau of Land Management from 1978 to March 2009, with Mac's son Sam joining the partnership in 2003. Shown here, the 2L brand was used for calves sold commercially by the Empire Ranch, LLC, the Donaldsons' ranching company. Each member of the Donaldson family owned some of the cattle in the herd. The K brand was used by John for his cows and bulls, XV was the brand for Mac and Billie's cows, and 3Z was the brand for Sam's cows. The SJ brand was used for horses owned by Sam and his wife, Jennifer. It is not unusual for a rancher to have several brands to represent different ranches, different time periods, or different meanings.

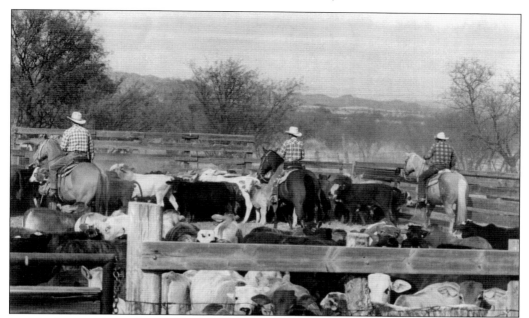

In this photograph, cowhands Tom McCoy (left), Juan Tellez (center), and Fernando Leon ride among calves at the "shipping pens" south of the Empire Ranch headquarters during the fall roundup in 1993. The calves have just been weaned, or separated, from their mothers and are ready to be shipped to market. (Courtesy of the Donaldson family.)

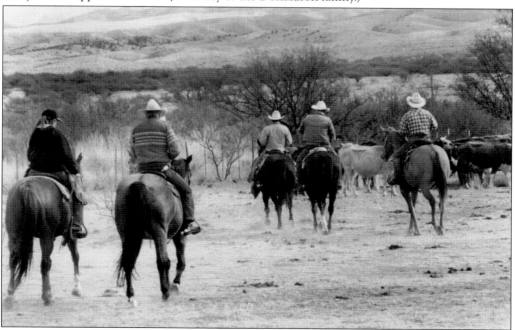

Riding out with the cattle on the Empire in 1993 are, from left to right, Billie Donaldson (wife of Mac), John Donaldson, and cowhands Juan Tellez, Fernando Leon, and Tom McCoy. In the background are the Whetstone Mountains, which border the Empire Ranch on the east and are part of the Coronado National Forest. (Courtesy of the Donaldson family.)

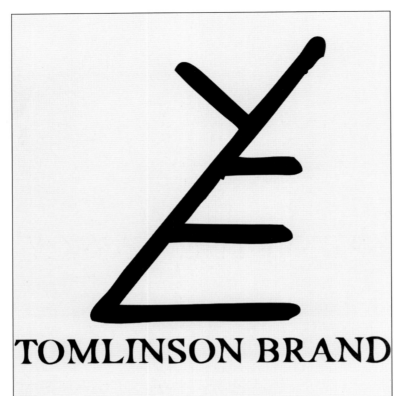

TOMLINSON BRAND

In March 2009, Ian Tomlinson, of the neighboring Vera Earl Ranch, entered into a grazing lease agreement with the Bureau of Land Management to run cattle on Las Cienegas National Conservation Area. Ian continues the family cattle ranching tradition begun by his grandparents Burton and Bettie Anne Beck in 1968.

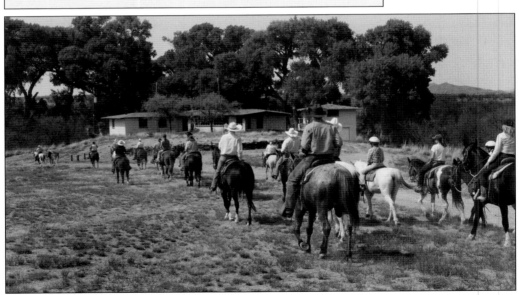

Riders set off on a trail ride on the Empire Ranch in 2010. They are headed to the riparian area, the row of cottonwoods along the Empire Gulch just north of the Empire Ranch headquarters. Just like the Empire Ranch cowhands, they wear long-sleeved shirts, hats, jeans, and boots to protect themselves from the harsh desert weather and prickly plants. (Courtesy of Gary Auerbach.)

Six

CONTINUING THE LEGACY

If you can't economically ranch within the environment's ability to be productive without using artificial means, you better get into another line of endeavor.

—John Donaldson

The end of the Boice era ushered in a new period of ranching traditions and innovative range management practices on the Empire Ranch. The Donaldsons, an enterprising family with a love of the land, arrived at the Empire.

In 1974, Anamax Mining Company purchased the Empire from the Gulf American Corporation for the water rights to develop a mine on its Helvetia claim in the Santa Rita Mountains. After Anamax discontinued the grazing lease with the Boices, the company's general counsel entered into a favorable agreement with southern Arizona rancher John Donaldson. In 1975, Anamax agreed to put up the land for the tax benefits. Donaldson agreed to make an experimental start by running 17 head of cattle on the Empire. He and his wife, Janet, made Empire Ranch their home.

Anamax purchased another ranch north of the Empire, called the Cienega. The combined open rangeland of the two ranches totaled 72,000 acres. Donaldson established three extensive pastures. For the next 15 years, he developed a one-herd grazing concept, in which the herd was rotated to different pastures, as an alternative to the one-pasture, year-round system of grazing.

John's son Macfarland "Mac" Donaldson and his wife, Billie, joined the partnership in 1978. Their family lived on the Cienega Ranch, and Mac helped manage the ranching operation with John. In 1988, the Bureau of Land Management acquired the Empire Ranch and established the Empire-Cienega Resource Conservation Area. The Donaldsons continued their grazing lease but had to live elsewhere. By 2000, Empire Ranch became the heart of Las Cienegas National Conservation Area (LCNCA).

Mac's son Sam joined the partnership in 2003. Sam and his wife, Jennifer, added a horse-breeding program to the operation in 2005. The Donaldson clan continued using productive, resource-restoration practices until March 2009, when the Tomlinson family assumed the Donaldson lease. The legacy of the Empire Ranch lives on.

John Donaldson was always fond of the idea of being a cowboy because "cowboys could do their work on horseback." At the age of 13, John's family in New York sent him to a ranch school for boys in Tucson—from then on, he was hooked on the West. This experience influenced his career as a cattle rancher in the Southwest. (Courtesy of the Donaldson family.)

Here, John Donaldson is attending to details at Empire Ranch headquarters. John began cattle ranching in 1946, running cattle in Sonoita around that time on a ranch adjacent to the Empire Ranch. John owned cattle ranches in New Mexico and Pima County before leasing land and the Empire Ranch in 1975. (Courtesy of the Donaldson family.)

Shown here is the Huachuca House as it appears today, viewed from the master bath window of the Empire Ranch House. John and Janet Donaldson made the Huachuca House their home when they first moved to the Empire. John said he was never much interested in the type of roof he had over his head, as long as it looked decent and there were nice paintings inside. (Photograph by Timothy Corkill.)

John and Mac Donaldson used a nontraditional rotation system of cattle grazing that they developed over a 34-year period. The practice involves moving a large herd to different pastures, during different seasons, and for shorter durations. Using this sustainable system, plants are rested, the grasslands are not overgrazed, and the natural resources are allowed to recover. In this photograph, cattle graze in the pasture near the Empire Ranch headquarters. (Courtesy of Annie Helmericks-Louder, Jean Aspen.)

The Empire Ranch was up for sale in 1988 when the Anamax Mining Co. decided not to develop its mining operation in the Santa Rita Mountains. Anamax traded the land and the Empire Ranch to the Bureau of Land Management (BLM) for land in Maricopa County that eventually wound up in the hands of land speculators. Under a leasing arrangement, John, Mac, and Sam Donaldson ran 1,500 head of cattle on the 72,000 acres of public land now owned and operated by BLM. Mac handled the business operations, as well as all communications with community conservation partnerships and government agencies. Federal and state grazing leases are the reality for Arizona ranchers. Many ranchers have one federal or state permit, usually tied to a small private landholding. In this photograph, Mac Donaldson (left) and Elgin rancher Bill Schock (right), a member of the Empire Ranch Board of Directors, demonstrate branding at the 2011 Roundup & Open House. (Photograph by Christine Auerbach.)

Pictured is the east side of the Empire Ranch headquarters, situated in the heart of the 42,000 acres of public land that constitute Las Cienegas National Conservation Area (LCNCA). From 1975 to 1988, John Donaldson had a beneficial lease on the Empire with the Anamax Mining Co., in which money was put toward improving the natural resources. In 1988, the Bureau of Land Management (BLM) acquired the Empire and administered the land as the Empire-Cienega Resource Conservation Area. The region containing the Empire Ranch was designated a national conservation area by the US Congress in 2000. Among the resources of LCNCA that led to its designation are numerous water sources; unique and rare habitats, including cienegas, cottonwood-willow riparian forests, sacaton grasslands, mesquite bosques, and semidesert grasslands; and a diversity of animal species. Local rancher Ian Tomlinson of the Vera Earl Ranch in Sonoita, Arizona, assumed the Donaldsons' grazing lease agreement with BLM after John Donaldson retired in 2009. (Photograph by Timothy Corkill.)

The topography of the country, the five rare habitat types of the Southwest, and the varying climates appealed to John Donaldson when he first leased the Empire Ranch land from the Anamax Mining Co. in 1975. Anamax had acquired the Cienega Ranch in 1977. This resulted in three environments for raising cattle—the grassland prairies adjacent to Sonoita (summer); the sacaton deltas adjacent to the Cienega Creek (spring); and the Empire and Whetstone Mountains (winter). Cienega Creek, with its perennial flow and lush riparian corridor, forms the lifeblood of Las Cienegas National Conservation Area. The riparian zone is depended on by 90 percent of the wildlife in the national conservation area. This photograph shows the lush perennial stream and cienega creek and cottonwood-willow forest habitats of LCNCA. A Fremont cottonwood is reflected in the pool of water. (Courtesy of BLM.)

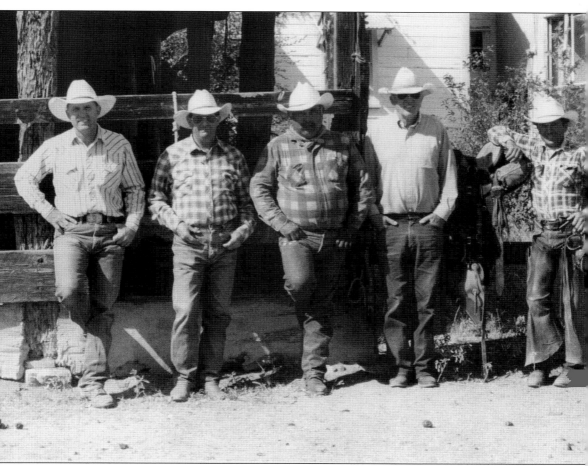

Shown here relaxing at the stone corral after a roundup in 1993 are, from left to right, Mac Donaldson, Tom McCoy, Fernando Leon, John Donaldson, and Juan Tellez. The stone corral has been used for over a century on the Empire Ranch. The Vails used it for their stallions, the Boices primarily for storage of wood. The children's addition of the Empire Ranch House is visible behind them. John, his son Mac, and grandson Sam forged a one-herd, cow-calf operation using Brahman cross, Angus, and some Hereford bulls. The Donaldsons used the Empire Ranch as their headquarters for their partnership cattle operation and horse-breeding program. For over 34 years, they operated Empire Ranch, LLC, using environmentally friendly methods of cattle grazing. John contends, "There's nothing aesthetic about cattle ranching. It's a tough, dirty business." (Courtesy of the Donaldson family).

Mac (left) and Billie Donaldson moved to the Empire Ranch in 1978. They first lived on the Cienega Ranch, which became part of the Empire when Anamax purchased it in 1977. Mac and Billie's three children, Alexa, Sam, and Renée, were raised on the Empire. Mac delivered daughter Renée at Cienega Ranch. (Courtesy of the Donaldson family.)

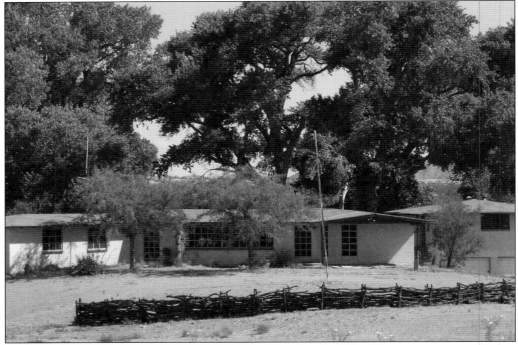

For a time, Mac and Billie Donaldson lived at the "Boice House," known as the new ranch house at Empire Ranch headquarters, near Mac's parents, John and Janet. They moved off the Empire in 1988 when the ranch was purchased by the Bureau of Land Management. Mac and Billie returned as ranching partners with John Donaldson in 1992. (Photograph by Timothy Corkill.)

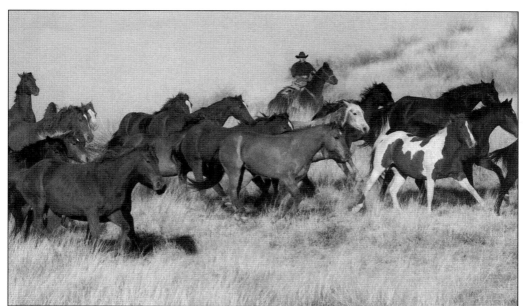

Mac Donaldson is shown here herding the cavvy (in southern Arizona, this adaptation of a Spanish word refers to a band of broodmares and foals). The Donaldsons kept 40 head of horses on the Empire as part of the ranch horse program, 25 of which were the remuda. The rest of the cavvy were turned out to breed. A love and appreciation of horses is a Donaldson family tradition. (Courtesy of the Donaldson family.)

Billie (left) and Sam Donaldson have a mother-son talk out on the range. Billie believes ranching as a livelihood is passed on from father to son. "You really can't go to school and learn about it. You really don't understand it until you get out on the ground." Mac taught Sam cowboy skills and methods of range management, as his father, John, had taught him. (Courtesy of the Donaldson family.)

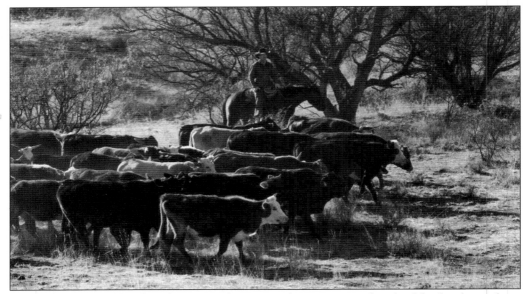

Sam Donaldson and local cowboy Joe Maloney were the primary cowhands of the family ranching operation. They were responsible for most of the day-to-day cowboy work, trading labor with other ranches in the spring and fall when more help was needed for roundups. Sam is shown here moving cattle on the range north of Empire Ranch headquarters. (Courtesy of the Donaldson family.)

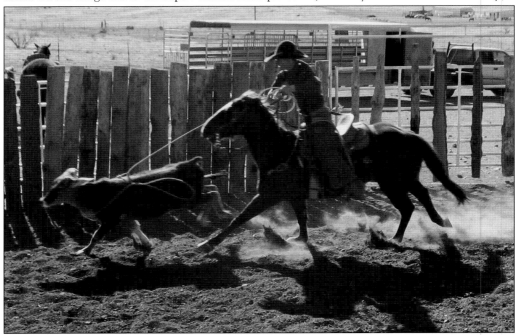

Sam Donaldson is pictured here roping a calf. He rode in high school and college rodeos, and competed in the professional ranks. In 1999, he won the title of Turquoise Circuit Saddle Bronc Riding Rookie of the Year. He earned an undergraduate degree in range management from Texas Christian University and went on to manage two ranches before becoming a business partner with his grandfather and father. (Courtesy of the Donaldson family.)

The only way John Donaldson wanted to work is on horseback. John initially leased the Tanque Verde Ranch in Tucson. In 1952, he owned the Tortuga Ranch in Avra Valley, and in 1960, he purchased the Diamond Bar Ranch, near Silver City, New Mexico. Here, John (left) and grandson Sam return horse equipment to the tack room at the end of a fine ranching day. (Courtesy of the Donaldson family.)

According to John Donaldson, Mac "has become very proficient; understands ranching very well now; is excellent, much better than I am, with people, and more patient. . . . I just think I'm getting old and crotchety." The photograph shows, from left to right, Mac Donaldson, US Supreme Court justice Sandra Day O'Connor, and Marion Hyland, past president of the Empire Ranch Foundation, after Marion's tour of the Empire Ranch House. (Courtesy of Robert McGregor.)

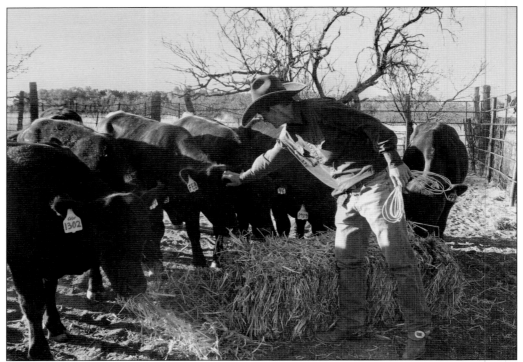

The Donaldsons' range management practices have helped to restore the resources of Las Cienegas National Conservation Area. For many years, Mac and John worked with the Sonoita Valley Planning Partnership to develop community-oriented solutions to issues that affect public lands. Sam Donaldson is shown here feeding some of the cows rounded up in the corral at the end of the day. (Courtesy of the Donaldson family.)

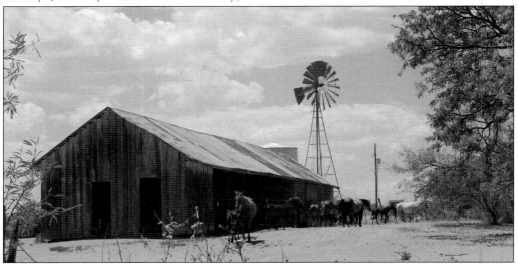

Pictured by the south barn is part of the Donaldson remuda, or herd of working horses. Mac and Sam Donaldson kept Thoroughbred and quarter horse mares for their breeding program. Saddle horses were kept in a separate pasture and fed grain in the morning to ensure they were ready to return to work the cattle. (Courtesy of the Schorr family.)

This photograph taken in 2006 shows Renée Donaldson (left) in the east corral with her grandfather John Donaldson and father Mac (right) after returning from helping with the family cattle operation. Like their Aunt Renée, niece Mackenzie and nephew Colton love riding the range with their father Sam and grandfather Mac. (Courtesy of the Donaldson family.)

In 2004, Sam Donaldson and his wife, Jennifer, purchased two stallions from the Leachman Hairpin cavvy in Billings, Montana, for breeding with the Donaldson mares. Both stallions have excellent bloodlines for high-quality horses. Jennifer (left) and the daughter of a neighboring rancher make friends with one of the new foals. (Courtesy of the Donaldson family.)

Las Cienegas National Conservation Area is a wildlife corridor from Mexico through the "sky island" mountain ranges in southern Arizona. In the 1980s, pronghorn antelope were reintroduced to the area. The aim of the national conservation area's restoration program is to repopulate the semidesert grassland areas where the pronghorn once existed in Arizona. (Courtesy of Netzin Steklis.)

John, Mac, and Sam Donaldson adapted their practices, working closely with biologists and botanists, to help preserve endangered species and enhance riparian areas on the national conservation area. In this photograph, three unidentified teenagers on a hike near the Empire Ranch stop to observe pronghorn they spotted in the grasslands and the oak-studded hills of the national conservation area.

This illustration represents the personal connection middle school students made to the wildlife of the native grasslands and the spectacular view of the landscape that surrounds the Empire Ranch. The student-created design and interpretive text (not shown), titled *Youth in Las Cienegas National Conservation Area: Pronghorn Antelope Range*, is the content of a visitor information panel at the entrance of the Empire Ranch headquarters. The national conservation area contains some of the rarest habitats of the American Southwest and provides the necessary food, water, and cover for a variety of wildlife and plants. (Graphic design by students of Wild About the Grasslands! Summer Camp 2009.)

Shown in this portrait of four generations of the Donaldson cattlemen are, from left to right, Mac, Sam, Colton, and John Donaldson. In 2002, John received the Chester A. Reynolds Memorial Award from the National Cowboy & Western Heritage Museum. Two years later, the Donaldson family received the Clarence Burch Award from the Quivara Coalition for their innovative ideas in range management that restore the resources of the Western rangelands. In March 2009, the Donaldsons discontinued their ranching operation at the Empire and Las Cienegas National Conservation Area. John died in October 2009. Mac and Billie Donaldson continue ranching at their ranch in Elgin, Arizona. Sam and Jennifer Donaldson work on a nearby ranch north of Sonoita. (Courtesy of the Donaldson family.)

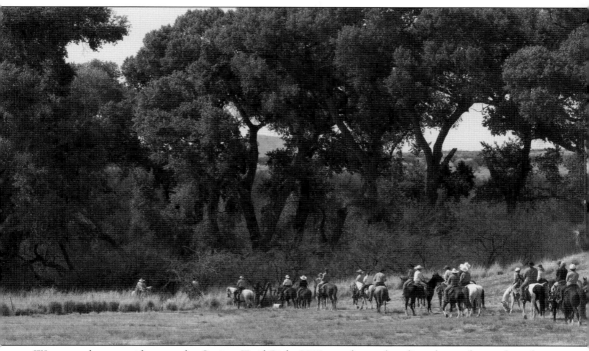

Western pleasure riders on the Spring Trail Ride 2010 are shown heading down the trail to the Empire Gulch nearby the new ranch house. The Empire Gulch, with the ribbon of Fremont cottonwood trees, is seen behind the drought-tolerant grasses that dominate the semidesert habitat. In an area once facing an uncertain future that included housing and mining development, more than 42,000 acres of southern Arizona grasslands, woodlands, and riparian areas are today protected and managed by the Bureau of Land Management as Las Cienegas National Conservation Area (LCNCA). This national treasure's important resources include native grasslands, riparian areas, and cienegas; numerous endangered and sensitive species; the Empire Ranch, in the National Register of Historic Places; and cultural resources from over 7,000 years of human occupation. LCNCA's biologically and culturally diverse landscape is a valuable resource managed for many uses, including cattle grazing and a variety of recreational activities. (Photograph by Gary Auerbach.)

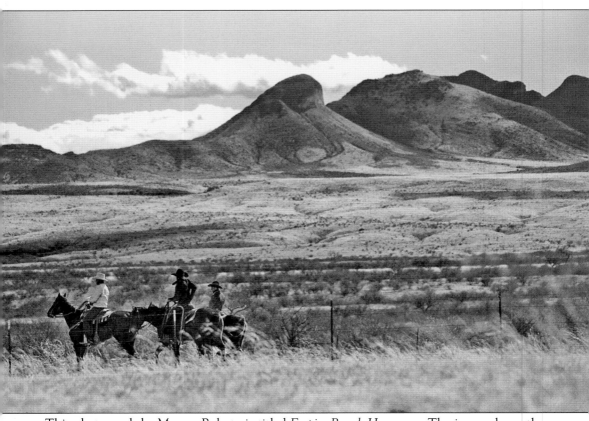

This photograph by Murray Bolesta is titled *Empire Ranch Horsemen*. The image shows three unidentified cowboys riding the rangeland of the Empire Ranch with the Mustang Mountains behind them as a backdrop to the natural and cultural landscape of Las Cienegas National Conservation Area. Former Empire Ranch ranchers Mac and Billie Donaldson are encouraged that people, especially youth, are taking an interest in the history and traditions of Empire Ranch. When they were interviewed in 2008, Mac pointed out that, with the continuation of cattle ranching on the Empire Ranch, "there's an economic aspect of what are you producing for society, which, in our estimation, is meat and fiber and leather and that sort of stuff. It's a product that is useful. And then, there's also the environmental aspect. That this is a viable watershed, it's intact. Wildlife habitat that is coexisting with our uses and, hopefully, it has a future for the future generations, your children, your grandchildren. That this will be here and there will always be that sort of part of the west." (Courtesy of Murray Bolesta/CactusHuggers Photography.)

Seven

INTO THE FUTURE

The Empire Ranch is not a Western movie about a cattle ranch. . . . It's the "Real Deal."

—Carla Kerekes Martin,
ERF president, 2009–present

From its humble beginnings some 36 years before Arizona achieved statehood in 1912, to now, the Empire Ranch continues to be an active, working cattle-calf operation. And cattle ranching on the Empire remains a family affair.

The Tomlinson family, owners of the Vera Earl Ranch, Inc., maintains a grazing lease agreement with the Bureau of Land Management (BLM). Since March 2009, rancher Ian Tomlinson has run F-I Bradford cattle on the 70,000 acres. Like previous lessees John and Mac Donaldson, Tomlinson works cooperatively with BLM to ensure that the rest/rotation method he uses for grazing is in compliance with the resource management plan for Las Cienegas National Conservation Area (LCNCA).

The Empire Ranch Foundation was established 15 years ago to preserve the Empire Ranch and its place in the history of cattle ranching in the Southwest. Through member and volunteer support and significant grants from BLM and private foundations, a variety of restoration and interpretation projects has been completed.

The foundation sponsors many events to showcase the Empire Ranch and raise public awareness of its rich history. The annual Roundup & Open House is a celebration of ranching traditions. This event has been expanded to include Legacy Day and Wild About the Grasslands! education programs. These programs bring youth to the historic Empire Ranch and provide hands-on outdoor classroom experiences to learn about ranching skills and the native species and rare habitats of LCNCA.

With a focused approach to preservation, interpretation, outreach, and education, the foundation's vision to transform the Empire Ranch into a Western heritage and education center will become a new chapter for the next generations to record. The tale of the Empire Ranch is a continuing story born out of the lives of the Vail, Boice, Donaldson, and Tomlinson families. The veritable story of the Empire Ranch, unlike the Hollywood films of the 1940s, lives on in the spirit of the Old West, with hope, determination, and the promise of tomorrow.

In this photograph, Empire Ranch is viewed from the west under a double rainbow. The Empire Ranch Foundation (ERF), working in partnership with the Bureau of Land Management, is dedicated to preserving and interpreting the Empire Ranch historic buildings, including the 22-room Empire Ranch House, is and the landscape that surrounds ranch headquarters for future generations. (Photograph by Brad Cooper, courtesy of BLM.)

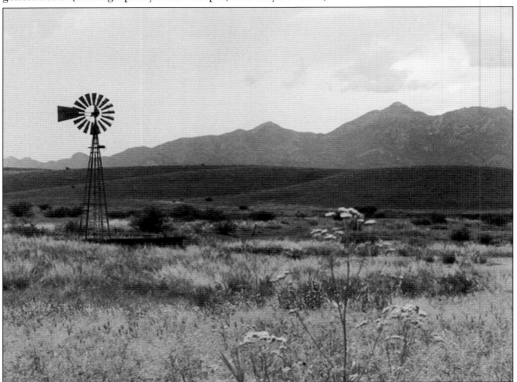

Pictured here are the Empire Ranch headquarters and the expansive natural landscape that surrounds this national historic site. The Santa Rita Mountains to the west overlook the rolling grasslands and mesquite-studded hills. The five rare habitats of this national treasure provide the necessary food, water, and cover for a variety of species, including 60 mammals, 230 birds, 43 reptiles and amphibians, and 3 native fish. (Photograph by Timothy Corkill.)

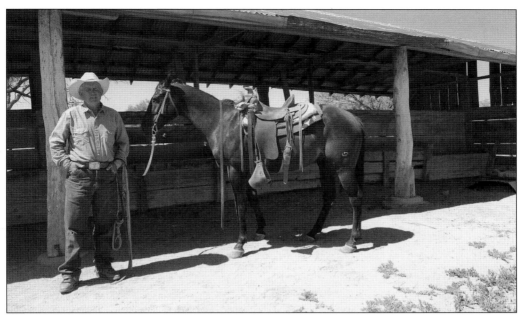

Mac Donaldson and his horse stand in front of the covered feed trough, built in 1900. From 1978 to 2009, John Donaldson, son Mac, and grandson Sam ran varied types of cattle on the Empire using a resource management system to restore the rangeland. Mac and his wife, Billie, ERF Advisory Committee members, have contributed countless hours volunteering for ERF outreach and education events. (Courtesy of the Schorr family.)

Ian Tomlinson finds time to teach visitors attending the 2011 Roundup & Open House about his family's ranching heritage. In 1968, Ian's grandparents, Burton and Bettie Ann Beck, established the Vera Earl Ranch in Sonoita, Arizona. He works with another cowhand year-round on Las Cienegas National Conservation Area. During spring and fall roundups, he hires a crew of eight to move the cattle to the Empire Ranch. (Photograph by Alison Bunting.)

The weak and deteriorated lintel—the large wooden beam above the south end of the zaguan, or breezeway—is examined by, from left to right, Eric Means, Gerald Korte, Terry Majewski, Mel Green, Bob Vint, and Chris Schrager. In 2009, Statistical Research, Inc. completed the structural repair of the lintel that allowed for the support port to be removed and created an unobstructed view. The zaguan is often referred to as the "Heart of the Empire." (Courtesy of Statistical Research, Inc.)

Recounting what the life of a ranch hand was really like, Gerald Korte leads tours of the Empire Ranch House for Empire Ranch Foundation events and youth education programs. Gerald first came to the Empire Ranch in 1946 at the age of 17 to cowboy for Frank and Mary Boice, staying until 1949. (Photograph by Susan I. Hughes.)

Empire Ranch Foundation (ERF) volunteers gather in the open corral area on the southeast side of the Empire Ranch House. Dedicated volunteers regularly assist BLM staff in maintaining Empire Ranch buildings and structures, and with landscaping. Others give monthly tours of the Empire Ranch headquarters and help with ERF events. The tack room, seen in the background, was constructed around 1900 by the Vail family. (Photograph by Gary Auerbach.)

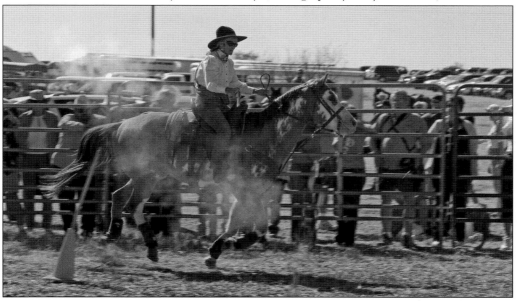

The Roundup & Open House is the Empire Ranch Foundation's family-friendly educational event. It draws 2,000 visitors annually to Empire Ranch headquarters the first Saturday in November. The event showcases the Empire Ranch headquarters and engages children and adults in the history and tales of the Old West. In this photograph, cowgirl Doreen Daiss performs with the Cowboy Mounted Shooters for a crowd of onlookers attending the 2010 roundup. (Photograph by Carl H. Sparfeld.)

In this photograph, over 100 riders, ranging in age from 9 to 84 years, are saddled up in front of the east side of Empire Ranch for the 2010 Spring Trail Ride sponsored by the Empire Ranch Foundation. All are ready to head out under the direction of trail boss Steve Boice and his daughter,

Faith Boice, to experience the spectacular scenery of Las Cienegas National Conservation Area. Shown behind the riders are the outbuildings and historic Empire Ranch House. (Photograph by Gary Auerbach.)

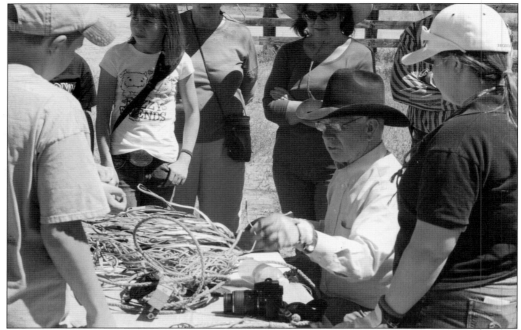

Dick Schorr (right, seated), founder of Legacy Day, shares his expertise in rope braiding as ERF president Carla Kerekes Martin (center, with hat) and his granddaughter Caitlyn Coleman (far right) watch. Dick is nationally recognized for the Western art form of reata rawhide braiding for making horse gear. The students of Elgin School learn about their ranching heritage from local ranchers and cowhands. (Photograph by Cheryl Rogos.)

Elgin Middle School students celebrate the completion of a 100-foot-long retaque fence they constructed with mesquite wood during Legacy Day 2007. Rancher Joe Quiroga taught them firsthand the way the vaqueros confined livestock in southern Arizona and Sonora, Mexico. The buildings visible in the background are, from left to right, the original, four-room adobe house, the Victorian addition, and the south barn. (Photograph by Christine Auerbach.)

Posed in front of the Empire Ranch House are the youngsters, teen leaders, and field instructors of the 2010 Wild About the Grasslands! (WATG) Nature Heritage Discovery Summer Camp. In 2007, Empire Ranch became an official member site of the Hands on the Land national network of field classrooms. Wild About the Grasslands! is an ecology and Western heritage program sponsored by the Bureau of Land Management and Empire Ranch Foundation. (Courtesy of WATG.)

Steve Boice, past president of the Empire Ranch Foundation, drives his team of Percheron horses to give Wild About the Grasslands! (WATG) students a wagon ride around the Empire. In 2011, the Boice family, five generations of Arizona ranchers, received the College of Agriculture and Life Sciences Heritage Family Award for their support of The University of Arizona and contribution to agriculture in Arizona. (Courtesy of WATG.)

BIBLIOGRAPHY

Bailey, Lynn R. *We'll All Wear Silk Hats: The Erie and Chiricahua Cattle Companies and the Rise of Corporate Ranching in the Sulphur Springs Valley of Arizona, 1883–1909.* Tucson: Westernlore Press, 1994.

Barr, Betty. "Arizona's Empire." *Range Magazine* (Summer 2004): 48–52.

Conover, Adele. *Keepers of the Range: The Story of the Arizona Cattle Growers' Association, 1903–2006.* Phoenix: Heritage Press, 2007.

Dowell, Gregory Paul. *History of the Empire Ranch.* MA thesis, University of Arizona, 1978.

Empire Ranch Foundation. *Docent Training Manual.* Sonoita, AZ: Empire Ranch Foundation, 2012.

———. *The Empire Ranch House: A Brief History.* Sonoita, AZ: Empire Ranch Foundation, 2009.

———. *The History of the Empire Ranch* (time line). Sonoita, AZ: Empire Ranch Foundation, 2001.

———. Newsletters, 2000–2012.

———. Oral histories of Bob and Miriam Boice, Mary Boice, John Donaldson, Mac and Billie Donaldson, Harry Heffner, Annie Helmericks-Louder, Norman Hinman, Susan Vail Hoffman, Laura "Dusty" Vail Ingram, and Gerald Korte.

Heffner, Harry. "Reminiscences about Empire Ranch, 1960." Interviewed by Charles U. Pickrell, June 4, 1960. Empire Ranch Foundation archives.

Hislop, Herbert R. *An Englishman's Arizona: The Ranching Letters of Herbert R. Hislop, 1876–1878.* Tucson: Overland Press, 1965.

Hunt, Sharon. "The History of the La Posta Quemada Ranch, Vail, Arizona." Tucson Corral of the Westerners. *The Smoke Signals* 82 (June 2007).

LeRoy, Tammy. "Desert Empire." *Western Horseman* (July 2006): 38–43.

Shaus, Richard G. "Hereford Tradition of Arizona's Boices Is Deeply Rooted." *Hereford Journal* (July 1, 1959): 240, 241, 244, 248, 252, 253, 256, 724, 726–728, 730–732, 734–738.

Shirley, Christine. "Establishing an Arizona Family." Unpublished manuscript, c. 1978. Empire Ranch Foundation archives.

ABOUT THE
ORGANIZATION

These old buildings do not belong to us only, they belong to our forefathers and they will belong to our descendants unless we play them false. They are not in any sense our own property to do with as we like with them. We are only trustees for those that come after us.

—William Morris

The Empire Ranch Foundation is a 501(c)(3) organization established in 1997. The foundation has been established to protect, restore, and sustain the Empire Ranch historical buildings and landscape as an outstanding Western heritage and education center. We are partners with the Bureau of Land Management. The ranch headquarters are located on Las Cienegas National Conservation Area, located 45 miles southeast of Tucson, Arizona, on Highway 83.

Since the establishment of the Empire Ranch Foundation, we have grown to a membership base of over 500 members. Gail Waechter Corkill, our education director, has developed and implemented the Wild About the Grasslands! (WATG) education program for youth. This program is nationally recognized. WATG is part of the National Hands on the Land program, which has field classrooms all across the United States.

Our members are passionate about preserving the picturesque handmade adobe buildings that were first built in the early 1870s. The legacy of the Empire Ranch and the entire ranching history of the West were vital to the development of the United States. It is the responsibility of all Americans to pass on these historic treasures to future generations. This is the story not only of buildings but also of individuals and families, of their joys, their struggles, their dreams—the story of life.

We are committed to educating the youth of today in the importance of American history, the necessity for historic preservation, and the ecology and biology of the surrounding grasslands. It is vital for all people to establish a personal connection to our environment and to our collective history.

It is an honor and privilege to be part of this wonderful organization, its mission, and the wonderful volunteers who give of their time, their energy, and their financial contributions.

For more information, to join, and/or to contribute to this valuable cause, please visit www.empireranchfoundation.org.

A sincere THANK-YOU goes from the board of directors to Sharon Hunt and Gail Waechter Corkill for their dedication and efforts in publishing this book.

—Carla Kerekes Martin
Empire Ranch Foundation president

DISCOVER THOUSANDS OF LOCAL HISTORY BOOKS FEATURING MILLIONS OF VINTAGE IMAGES

Arcadia Publishing, the leading local history publisher in the United States, is committed to making history accessible and meaningful through publishing books that celebrate and preserve the heritage of America's people and places.

Find more books like this at
www.arcadiapublishing.com

Search for your hometown history, your old stomping grounds, and even your favorite sports team.